LIQUID VACATION

77 REFRESHING TROPICAL DRINKS

ALSO BY P MOSS

(Fiction)
Blue Vegas
Vegas Knockout

LIQUID VACATION
77 REFRESHING TROPICAL DRINKS
from
FRANKIE'S TIKI ROOM
in Las Vegas

Written by
P MOSS

original drink recipes by

CHRIS ANDRASFAY

ALLISON HARTLING

MIKE RICHARDSON

Stephens Press ▪ Las Vegas, Nevada

Editing: Heidi Knapp Rinella
Book Design: Sue Campbell
Illustrations: Dave Cohen AKA Squid
Principal photography: Wes Myles, Ryan Reason and Jenn Burkart for
 Studio West Photography
Eli Hedley photo: courtesy of Bamboo Ben
Taboo Cove photo: Scott Lindgren
Vintage Vegas photos: courtesy of the Las Vegas News Bureau

Second Printing

ISBN: 9781935043744

STEPHENS PRESS
A Stephens Media Company

To order books:
http://www.frankiestikiroom.com/merch.html

Printed in Korea

CONTENTS

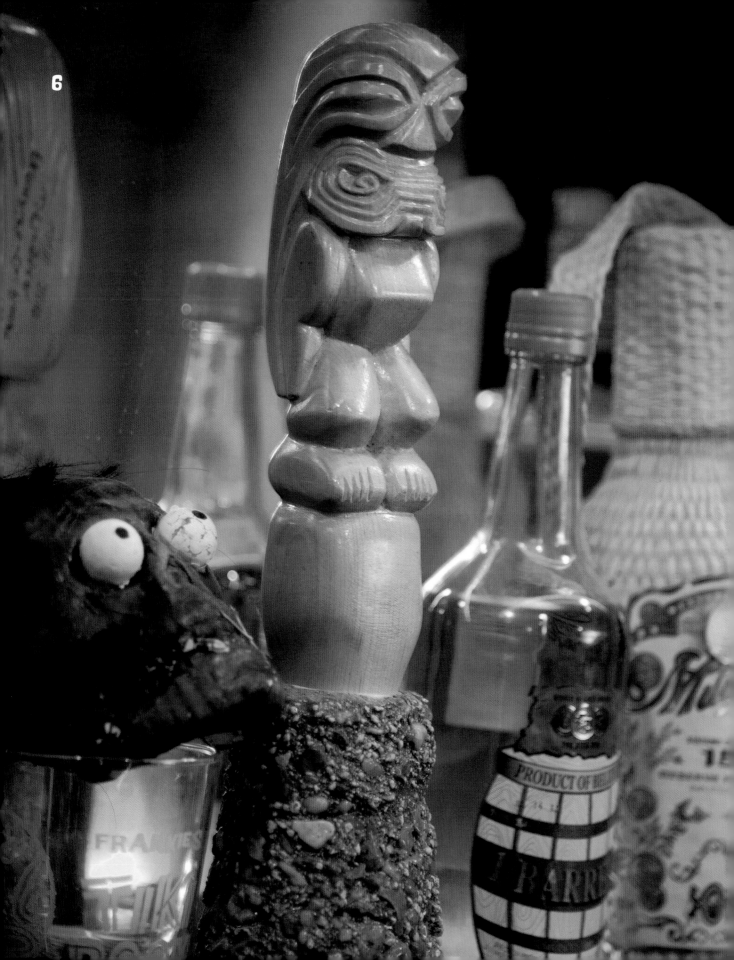

INTRODUCTION

There are many reasons why Frankie's Tiki Room is one of the most popular bars in the world. It's in Las Vegas. It's open 24/7. The cool parlay of tiki escapism and Vegas kitsch is without parallel.

On and on goes the list of reasons, but first and foremost is that the drinks are beyond fantastic. Frankie's versions of Polynesian classics such as the Mai Tai and the Zombie are as delicious as any you will ever taste, but it's the Frankie's originals that will send you into orbit.

The Lava Letch, the Fink Bomb and the Green Gasser are among sixty new classics created in-house by Frankie's mad scientists Chris Andrasfay, Allison Hartling and Mike Richardson, fun drinks with extraordinarily delicious blends of flavor that will stamp anyone's passport to the ultimate liquid vacation. They are drinks that buzz your brain and touch your soul. And now, drinks you can make easily at home.

Modern cocktail culture is too often elitist, both in attitude and application. Not everyone has access to small-batch spirits and exotically rare ingredients like shark tonsils or nectar from the first thimbleberry of spring. Nor is everyone's home bar equipped with a centrifuge, an induction burner and an atom smasher. And to make Frankie's exotic elixirs you don't need any of it, as every drink in this book can be crafted using basic bar tools from ingredients easily available. Drinks that are among the most delicious you will ever taste. Drinks that can be even more delicious when combined with the pride of making them yourself.

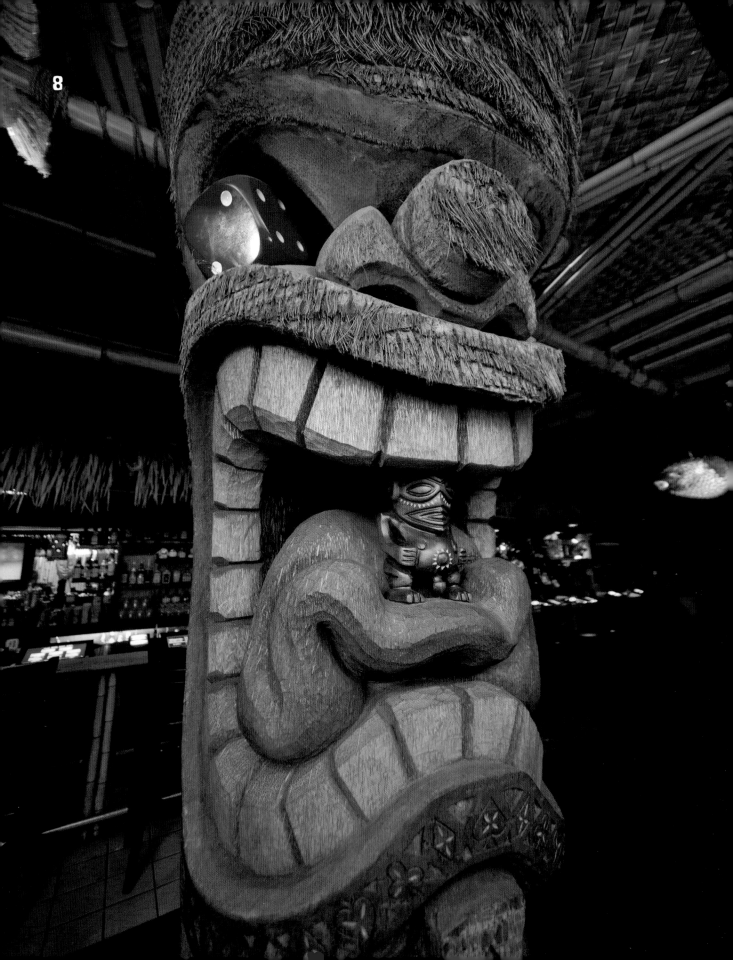

By the time tiki style exploded into American pop consciousness in the 1950s, California beachcomber Eli Hedley had already been at the forefront of the movement for more than a decade. From humble beginnings creating furniture and functional art from the flotsam that washed up on the doorstep of the home he had built from driftwood on the beach at San Pedro, it wasn't long before he had made a name for himself marketing his unique tropical décor.

The Hollywood community took notice, and Hedley's work started turning up not only in movies but in the homes of stars like Cary Grant, Jimmy Stewart and Vincent Price. Soon he was hired by a number of Los Angeles restaurant owners to install this new tropical décor that had captured the public's imagination. It also caught the eye of Walt Disney, who commissioned Hedley to decorate portions of Adventureland, and later the Enchanted Tiki Room, at his new theme park called Disneyland.

Walt Disney relocated Hedley, his wife and their four daughters to a patch of land across the street from Disneyland that the family affectionately named "the farm on Katella," where they lived and Hedley worked. Disney also leased them a retail store across from his Jungle Cruise attraction, where the family sold Hedley's tropical art. The arrangement worked out well for everyone until one day when some tough-looking men appeared and told Disney that they were taking Hedley to Las Vegas. There was no discussion, and just like that he was put in the back of a car and driven to the desert.

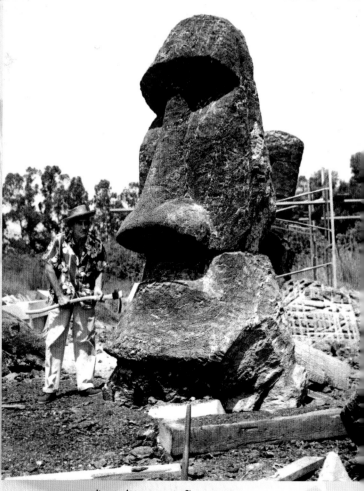

Eli Hedley carving a Moai.

AKU AKU

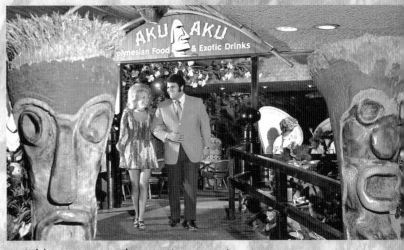

In Las Vegas, the mob-owned Stardust Hotel and Casino was preparing to cash in on the tiki craze with a Polynesian restaurant to be named Aku Aku, after the Thor Heyerdahl bestseller. Tropical drinks guru Donn Beach was brought in to consult on the menu, while master tiki carver Mick Brownlee worked on the interior design. Meanwhile, Eli Hedley was tapped to create the exterior décor—which he did, but only after the Stardust struck a deal with Walt Disney by which Hedley would work daily at Disneyland, then after hours craft the décor for Aku Aku at the farm on Katella.

Towering statues depicting the historic Moai idols of Easter Island were proposed to mark the entrance to Aku Aku but, because of the deal with Disney, the sculpting of these monoliths presented the unique problem of getting the raw materials to a place where Hedley could work on them. The problem was solved when the Stardust commissioned the mining of three thirty-foot blocks of volcanic featherstone from a quarry in northern Nevada and had them delivered to the farm. The finished Moai statues were then shipped to Las Vegas.

Aku Aku made an auspicious debut in 1960, due to an opening-night fire. But the damage proved minimal and the restaurant quickly re-opened, creating a unique niche on the Strip with the offering of Polynesian food and exotic drinks at a time when Las Vegas culture was bookended by tuxedos and cowboy boots. Tourists and locals alike made it a popular night spot for twenty years until it closed in 1980, the theme falling victim to America's suddenly waning love affair with all things tiki. The Stardust itself became a casualty of changing tastes when it was demolished by implosion in 2007.

Today, one of Eli Hedley's original Moai statues sits on a small island in a lake in Las Vegas' Sunset Park, where it can be seen across the water or from the air from planes arriving and departing at the nearby McCarran International Airport.

Another link between the Aku Aku era and modern Las Vegas is the interior of Frankie's Tiki Room, which was designed and built by Bamboo Ben, grandson of Eli Hedley, almost a half-century later.

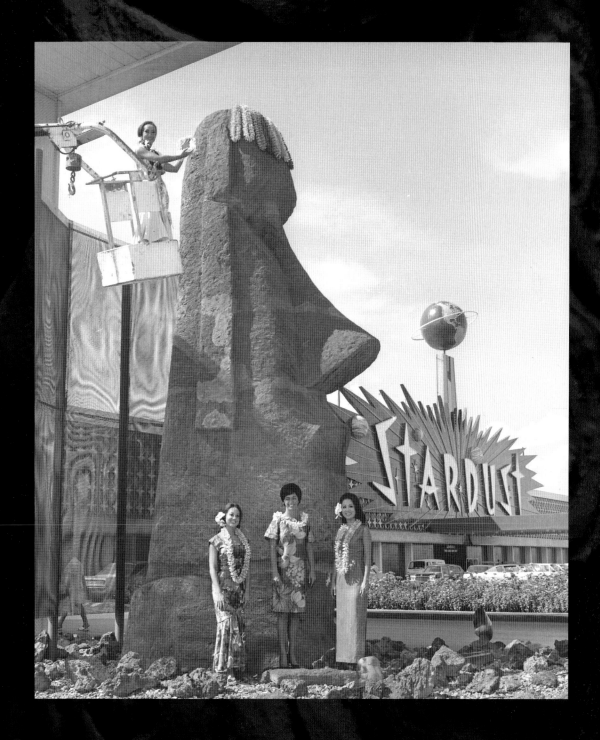

DON THE BEACHCOMBER

Adventurer Donn Beach, who had enjoyed the hedonistic delights of rum and sex on the laid-back islands of the South Pacific, brought his version of paradise to Hollywood when he opened his original Don Beachcomber Café in 1934. Three years later the café expanded and moved across the street, becoming a popular celebrity hangout fueled by his menu of potent tropical cocktails that included such soon-to-be classics as the Mai Tai and the Zombie.

Beach had always been more of a promoter than a businessman, and his ex-wife controlled the company when the restaurant was later franchised in cities including Chicago and Palm Springs. This made the man with his name on the sign at most an advisor when an outpost of Don The Beachcomber opened in Las Vegas at the Sahara Hotel and Casino in 1962. Though not quite as popular with locals as its iconic neighbor Aku Aku at the Stardust, Don The Beachcomber was every bit the Strip hot spot, with a Polynesian menu, exotic cocktails and dancing late into the night. But as Las Vegas transitioned from its imaginative anything-goes heyday to corporate cookie-cutter myopia, so, too, faded the frolicsome desert outpost of Don The Beachcomber, which finally crapped out in the mid-1980s.

THE CASTAWAYS, BALI HAI AND THE TROPICANA

Tikis and bits of tropical décor have popped up here and there since the 1950s, dotting the fabric of Las Vegas just as they do any sunny tourist destination. But three resorts—the Castaways, Bali Hai and the Tropicana—were first to capitalize on it as a theme, claiming important places in Las Vegas tiki history.

In 1931, on land that a generation later would become the center of the fabulous Las Vegas Strip, a roadhouse called the Red Rooster kicked up its heels just south of town on a desolate stretch of Highway 91. The property eventually became the Sans Souci Hotel, then in 1963 the Castaways Hotel and Casino, where naked mermaids frolicking in a 15,000-gallon aquarium were the main attraction. The Castaways was quickly sold and re-named Oliver's New Castaways Casino.

Oliver's New Castaways catered to a cost-conscious clientele, and did well with its restaurant, lounge and Pacific Island tiki-themed showroom (which for a time featured a sexually suggestive revue starring a young Redd Foxx). But due to stiff competition, mainly from the Sands across the street, the casino could never hold its own and finally waved the white flag of surrender in 1969, selling out to Howard Hughes, who changed the name back to the Castaways Hotel and Casino.

With a staff that wore Hawaiian shirts, the island style of Hughes' Castaways was a relaxing alternative to the fast-paced casinos surrounding it, making the intimate tiki-refreshed spot a happening locals' hangout for the next two decades. But as popular as its laid-back island style was, progress was the villain as the Castaways was bulldozed in 1987 to make way for the Mirage.

A short walk from the Strip and facing the Desert Inn Country Club, the Bali Hai opened for business in 1957, a sprawling 14-acre property with drive-up motel suites and kitchenettes, swimming pools, tennis courts, volleyball and a lush South Seas tropical-garden courtyard. Though there was no casino and, surprisingly, no restaurant, the Bali Hai was a hit with budget-conscious vacationers. And as it was only steps from the action of the Desert Inn, Stardust and Riviera, price made it an attractive long-term option for many casino employees and showroom performers until it was demolished in 1990 to make room for

expansion of the neighboring Guardian Angel Cathedral.

When the Tropicana Hotel and Casino opened in 1957 it was touted as "The Tiffany of the Strip." It lived up to its elite billing with the soon-to-be Folies Bergere Paris revue and an eighteen-hole championship golf course. But after three decades and several ownership changes, the property was floundering and in need of a facelift.

By 1991 the resort's "Island of Las Vegas" theme was in place, including a new tower, water park and two thirty-five-foot Moai statues similar to those that had once stood guard in front of Aku Aku. Also featured on the grounds in front of the hotel were large wooden images of Hawaiian gods Kalanui (money) and Lono (peace and prosperity), both created on-site by master tiki carver Ben "Benzart" Davis.

Benzart had been commissioned to spend two weeks carving at the Tropicana, but management was so thrilled with his work that he stayed on and off at the hotel for months, adding dozens of tikis to the tropical landscape—popular finishing touches that became the source of mystery a short time later when, without explanation, the Benzart tikis were retired to storage.

The Lono tiki was eventually rescued, and now stands guard in front of Frankie's Tiki Room.

TABOO COVE

With Aku Aku and Don The Beachcomber long shuttered, the Las Vegas tiki drought ended with the opening of Taboo Cove at the Venetian Resort Hotel Casino in 2001. Designed by Bosko Hrnjak (who later carved many of the tikis and tables inside Frankie's Tiki Room), Taboo Cove was not only at the forefront of the then-surging tiki revival, it was the first authentic tiki bar built in America since the early 1970s.

Taboo Cove was an eye-filling combination of the traditional and the vividly hip, with every detail artistically stunning. Though it was popular with the Las Vegas in-crowd, less-than-enthusiastic promotion and a bad location contributed to the bar never quite gaining the mainstream tourist appeal necessary for success, and sadly the doors closed in 2005.

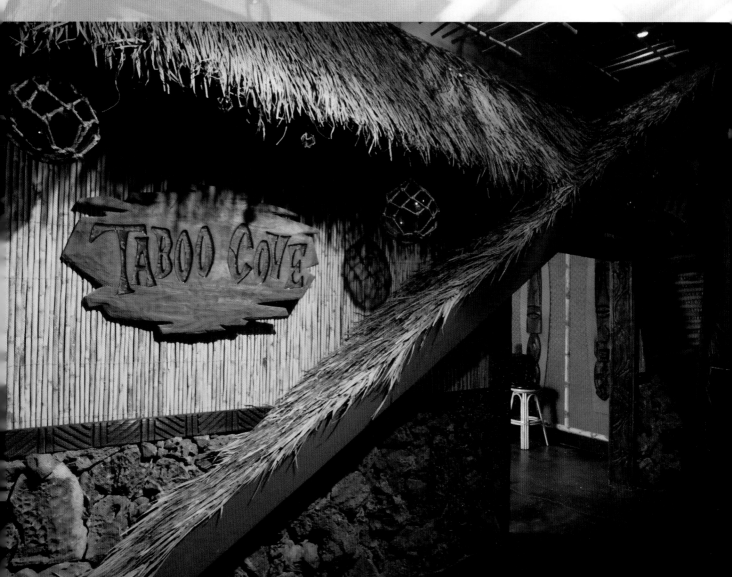

THE BIRTH OF FRANKIE'S

Frankie's Bar & Cocktail Lounge had been around since the 1950s—prehistoric by Las Vegas standards. The unassuming stand-alone building near downtown provided a welcoming haven for off-duty entertainers and craps dealers any hour of the day or night, a place where cocktail waitresses, keno runners and cab drivers could cut loose after a long shift grinding out the gratuities that fueled the economy of the twenty-four-hour desert town.

Over the years, new generations of regulars would come and go, eventually fading away for good as the proliferation of the Strip spawned newer, more upscale places to blow off steam after work. It wasn't long before Frankie's grew stagnant, deteriorating into disrepair before eventually being put up for sale.

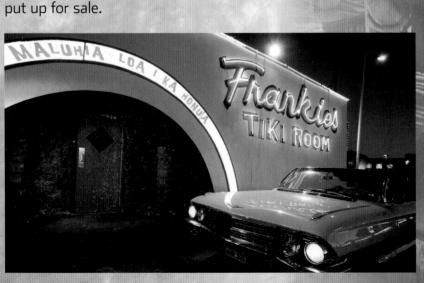

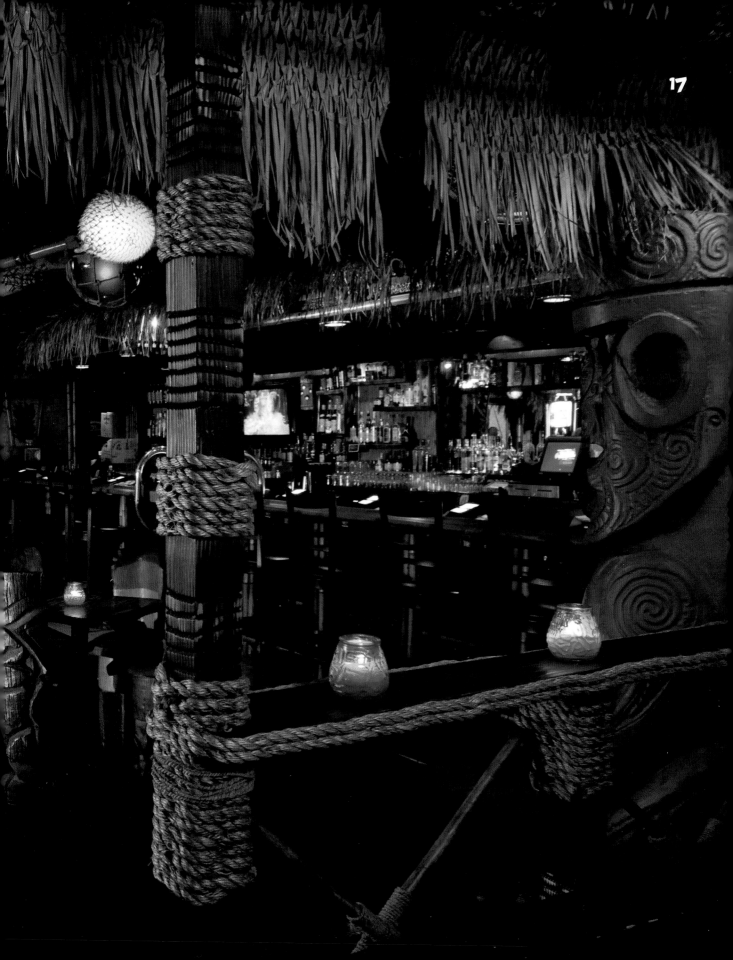

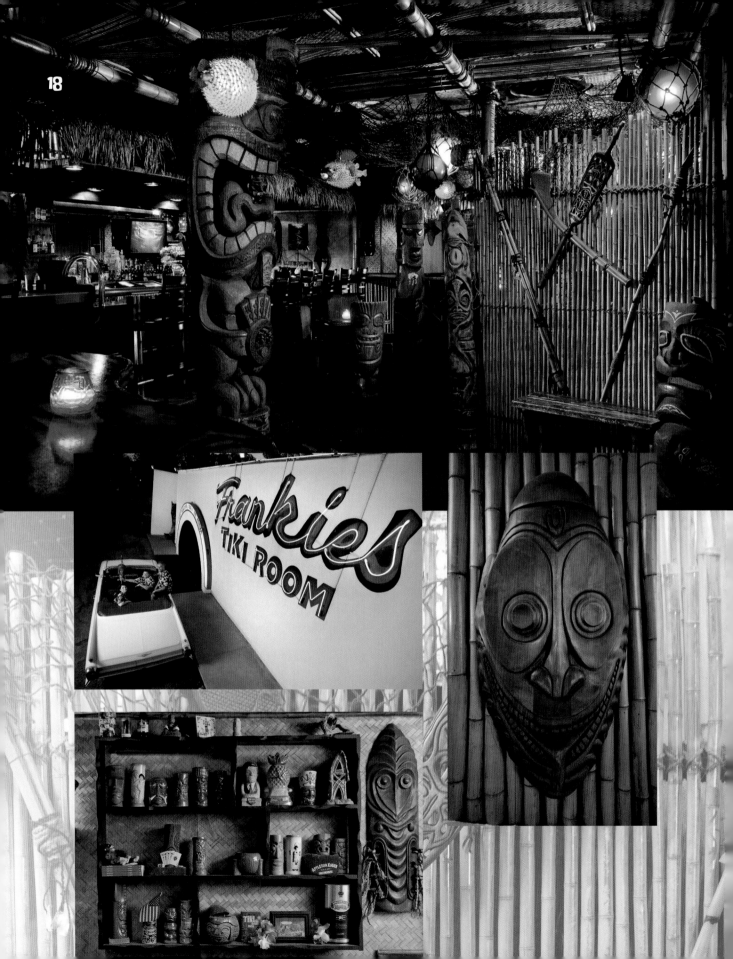

PUNK COLLIDES WITH POLYNESIAN POP

The Double Down Saloon is a legendary punk rock bar near the Strip, and owner P Moss and his partner, Chris Andrasfay, took it upon themselves to fill the glaring Las Vegas tiki void left by the closing of Taboo Cove. When Frankie's became available, they knew immediately that it was the ideal location for their new tiki bar. But what to call it?

Even old-timers disagree as to the identity of the original Frankie. Some swear the bar was named after Sinatra. Not true. Some say it was named after the wife of the original owner. Maybe. But whatever the origin, and despite the fact that most tiki bars have Polynesian-sounding names, rebranding the new concept was never considered and the name Frankie's was kept out of respect for a historic Las Vegas so many others are too quick to implode.

Many of the world's elite tiki carvers were approached to create the decor for Frankie's, but since both the project and the people involved were unknown to them, most declined, citing a backlog of other projects. Enter Bamboo Ben, the world's foremost builder of tiki bars and a fan of punk rock. He quickly made the Double Down Saloon connection and jumped at the opportunity to rebuild Frankie's, giving the project instant credibility and igniting a buzz within the tiki community. And on his recommendation, carving tikis for

Frankie's immediately became a priority for those who had earlier turned the project down. Top lowbrow artists were commissioned to create paintings and design tiki mugs. Furniture was carved. Fixtures were fashioned from bamboo, rattan and thatch, puffer fish and 100-year-old tapa cloth. Once all of the pieces had been assembled, Frankie's Bar & Cocktail Lounge was gutted and Bamboo Ben worked his magic. On December 4, 2008, Frankie's Tiki Room opened its doors to the public.

From hardcore tiki enthusiasts to the just plain curious, people marveled at the beauty of the bar. Deeply rooted in tiki tradition, the combination of South Seas exotica, lowbrow humor and Las Vegas kitsch not only was a hit, it gave Frankie's a unique personality all its own. But no matter how much people delighted in the atmosphere, Frankie's exotic rum drinks grabbed the spotlight, with the Fink Bomb, Thurston Howl and the Bearded Clam becoming instant sensations, side by side with delicious interpretations of revered classics like the Lapu Lapu and the Scorpion.

Frankie's had once again become a welcoming haven for off-duty entertainers and craps dealers to cut loose after a long shift, as well as anybody else seeking escape to the fantasy. The unassuming stand-alone building near downtown Las Vegas had become the launching pad that blasted the world's first and only twenty-four-hour tiki bar into orbit.

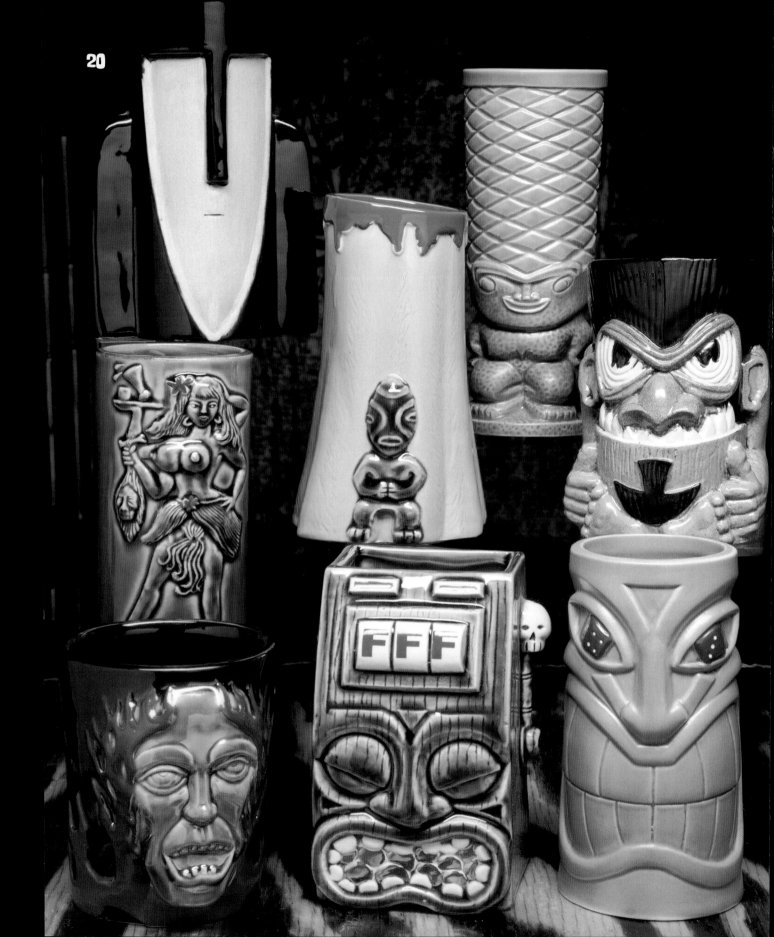

Whether it sparks the memory of a great vacation or that special first date, a tiki mug is the ultimate souvenir of a good time, a conversation-starting piece of functional art that can prove to be as valuable as it is personal, with serious collectors often forking over big bucks on eBay.

Tiki mugs first appeared in California in the 1950s, with Tiki Bob's in San Francisco and the Bali Hai in San Diego among the earliest restaurants to brand these quirky ceramic souvenirs. And it wasn't long before the promotional concept quickly spread to Polynesian-themed restaurants throughout America. Some of these vessels were artistically beautiful and some were crappy plastic knockoffs, but by the end of the decade the tiki mug had secured its place as an icon of American pop culture.

Early mug designs portrayed images of Hawaiian gods, Easter Island Moai idols and New Zealand Maori warriors, though it wasn't long before the fun side of tiki emerged with skewed lowbrow images of zombies, monsters and shrunken heads.

It was this fun side of tiki that fueled the ideas for the inaugural set of eight Frankie's mugs designed by a collection of artists including DaveCohen AKA Squid, Dirk Vermin, Von Franco, Sophia Brewer and Mark T. Zeilman. A slot machine. A sneering idol with dice eyes. A four-armed girl with a double smile. Both traditional and irreverent, these Frankie's mugs mirrored the image of the bar itself and became instantly collectible.

Limited-edition Frankie's anniversary mugs were created by revered tiki masters Crazy Al Evans, Benzart and Leroy Schmaltz. New designs by acclaimed artists Tom "Big Toe"Laura and The Pizz were added. And, of course, a special like-named drink went with every mug—or the truly adventurous might choose a Green Gasser in a Lava Letch mug or a Polynesian Pile Driver in a Malekula mug, the combinations as endless as the escapist dreams the mugs inspire.

Left: Original Frankie's Tiki Mugs. Right: Wild Watusi.

Broken Benzart

New Bearded Clam

Halloween Howl

Lucky Leroy

Crazy Al's High Roller

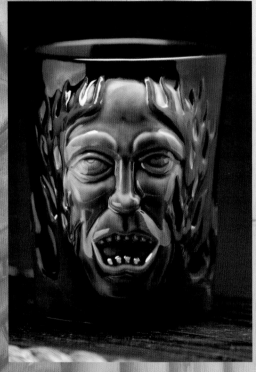

Green Gasser

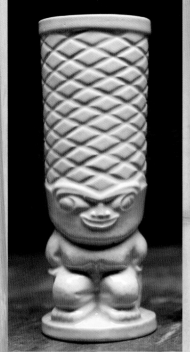

Kahiki Kai

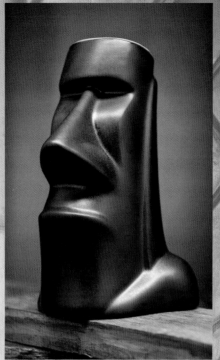

Malekula

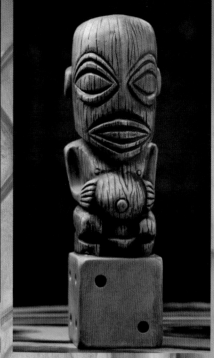

Squidzink

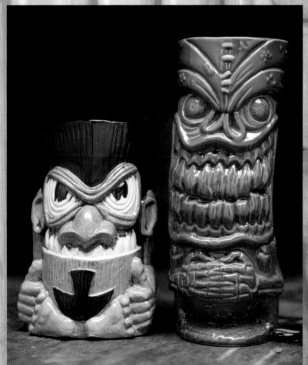

Original and New Lava Letch

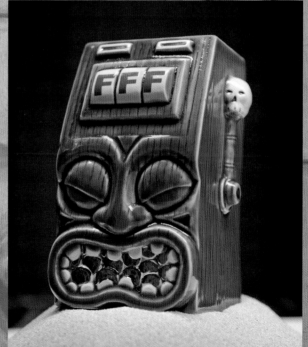

New Tiki Bandit

FRANKIE'S ORIGINAL TIKI DRINKS

💀💀💀 (More skulls equal more fun) 💀💀💀

Most tropically exotic drinks are variations of the basic formula: rum equals fun. And at Frankie's Tiki Room that equation is ramped up with the promise: More skulls equal more fun. Ranging from three-skull mellow to the five-skull kick-in-the-pants, the sixty original drinks by Frankie's creative geniuses are beyond refreshing, magical potions that are beyond fantastic. Served in a glass or the namesake tiki mug, these extraordinarily delicious drinks will punch your ticket to the ultimate liquid vacation.

For a list of preferred liquors and acceptable substitutes, see page 165.

For mixers and syrups, see page 166.

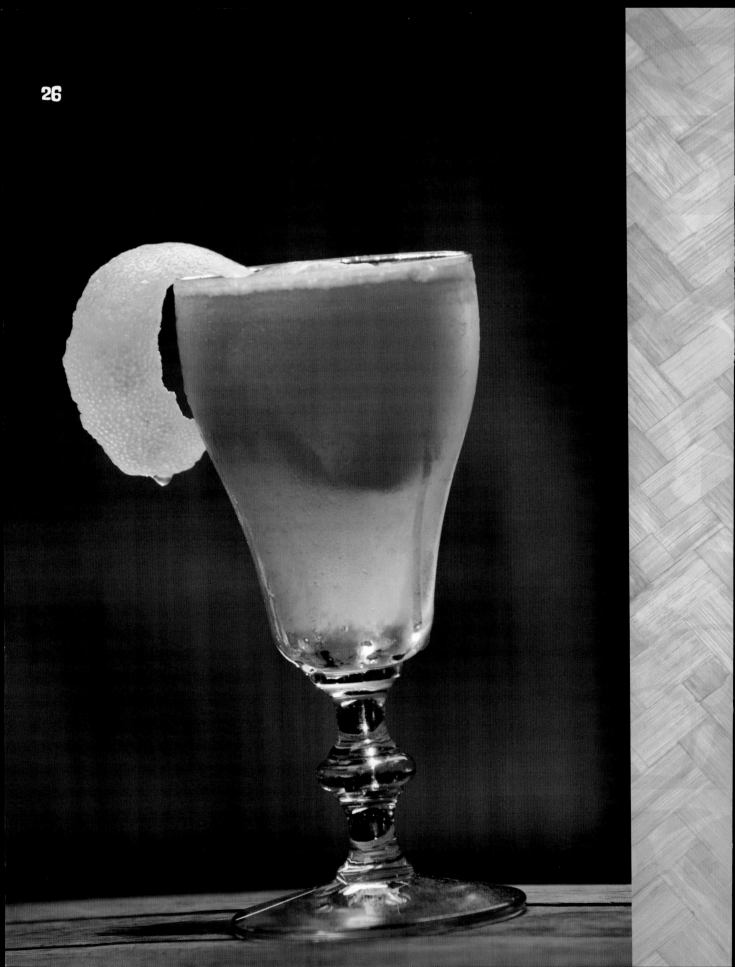

AH FOO

💀💀💀

A full-bodied cocktail named for the original date wrangler at the 19th-century Chinaman's Ranch. Now called the China Ranch Date Farm, this middle-of-nowhere desert oasis an hour west of Las Vegas is still going strong.

1½ ounces Pusser's rum

¾ ounce date syrup

3 drops Aztec chocolate bitters

1 ounce lemon juice

Lemon twist for garnish

Build ingredients over ice in a cocktail shaker. Shake well, then strain into an 8-ounce Irish coffee glass.

Serve garnished with a lemon twist.

BEARDED CLAM

💀💀💀

A couple of these fruity mint refreshers are guaranteed to part any grass skirt.

10 mint leaves

4 lime wedges

1½ ounces light rum

1 ounce simple syrup

1 ounce red passion fruit syrup

2 ounces club soda

Raspberries, for garnish

Mint sprig, for garnish

In a mixing glass, muddle the mint, lime, rum and syrups.

Add ice and shake, then pour into a 14-ounce double-old-fashioned glass and fill to the top with club soda.

Serve garnished with raspberries and a sprig of mint.

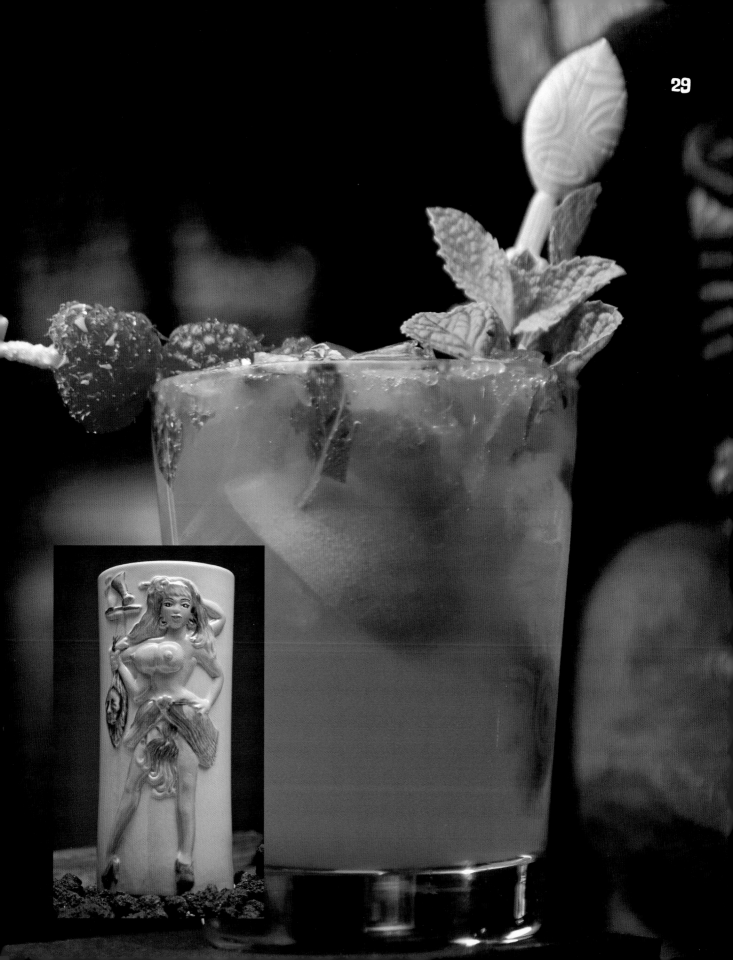

BENDER ENDER

To end a bender or start a new one, you can't go wrong with this numbing jolt crowned with a float of 160-proof rum.

½ ounce Cruzan Aged Dark Rum

½ ounce Sailor Jerry spiced rum

½ ounce falernum

4 ounces POG (passion-orange-guava drink)

Splash of 7Up

½ ounce Stroh 160-proof rum

Fill a 14-ounce double-old-fashioned glass with ice, then add aged rum, spiced rum, falernum, POG and 7Up.

Pour contents into a cocktail shaker. Without shaking, re-pour into the glass.

Float the Stroh rum on top.

Serve without garnish.

BLACK DUCK

A remarkable cross-breeding of flavors that will kick your buzz into high gear.

1½ ounces Solerno Blood Orange Liqueur

1 ounce Cruzan Black Strap Rum

¾ ounce Batavia Arrack

3 drops Aztec chocolate bitters

4 drops orange flower water

2 ounces 7Up

Lime wheel for garnish

Except for 7Up, build over ice in an 11-ounce chimney glass, then pour into a cocktail shaker.

Without shaking, re-pour into the glass, then top with 7Up.

Serve garnished with a lime wheel.

BOMBORA BLAST

💀 💀 💀 💀

An eruption of cherry, cranberry and guava detonated by 151-proof rum.
This flavor explosion will keep you soaring all night.

1 ounce Bacardi Gold rum

½ ounce Lemon Hart 151 rum

½ ounce cherry brandy

½ ounce lime juice

1 ounces cranberry juice cocktail

1 ounce guava nectar

2 ounces Rockstar energy drink

Lime wheel for garnish

Build over ice in a 17-ounce snifter.
Serve garnished with a lime wheel.

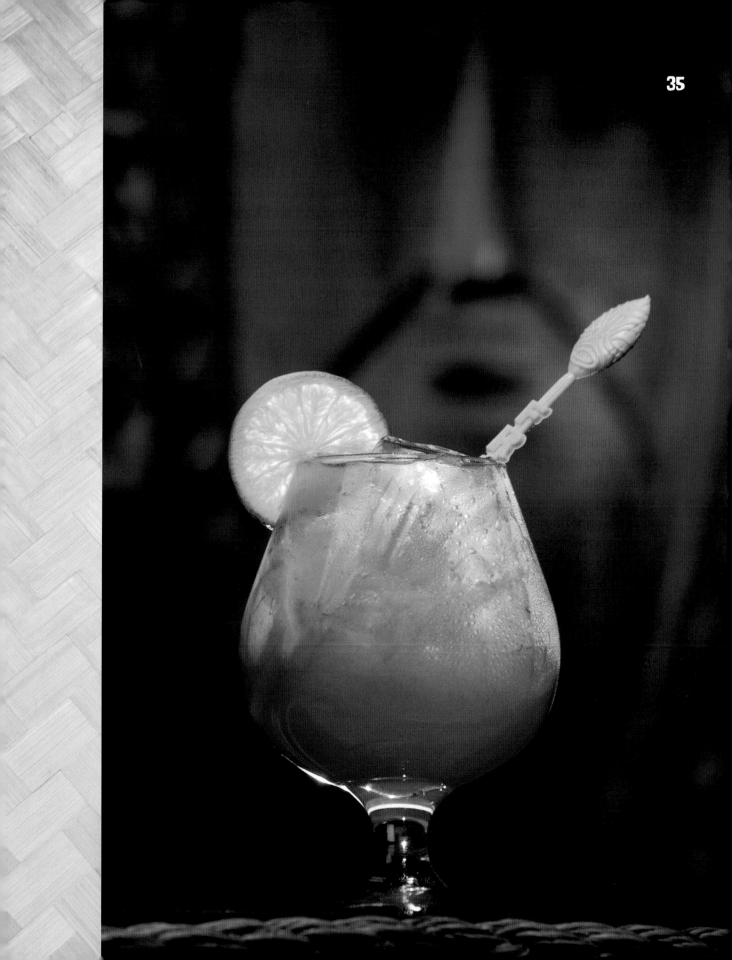

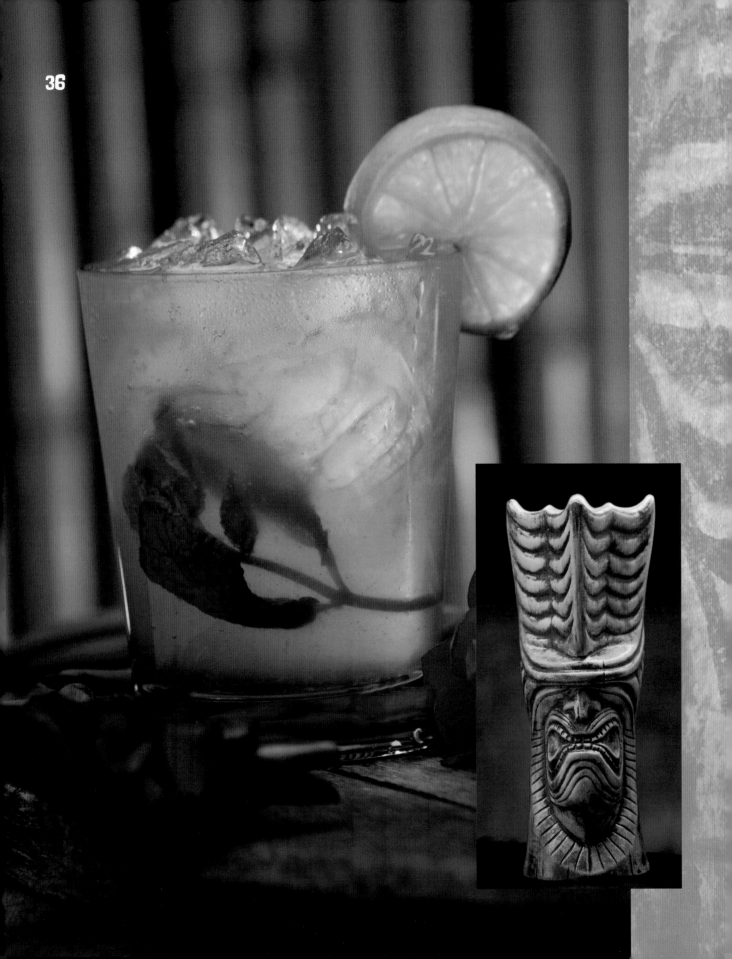

BROKEN BENZART

This drink was created for Frankie's third anniversary and the Benzart-designed limited-edition tiki mug commemorating the occasion. Inspired by the historic Benzart tiki that stands sentry outside Frankie's, this bewitching flavor medley is the perfect attitude adjuster. Be careful not to let your guard down.

1 ounce Mount Gay Eclipse rum

½ ounce blackberry brandy

½ ounce passion fruit syrup

¼ ounce falernum

¼ ounce lime juice

Dash Angostura bitters

1 ounce 7Up

1 ounce club soda

Sprig of mint

Lime wheel for garnish

Build over ice (except for mint) in a 14-ounce double-old-fashioned glass (or the commemorative tiki mug, if you are lucky enough to own one), then pour contents into a cocktail shaker.

Add mint, and without shaking, re-pour into the glass. Serve garnished with a lime wheel.

CALDERA CHILLER

Inspired by the whale-breeding basin between Maui, Lanai, Molokai and Ko'olawe. Chill, brah.

1 ounce Mount Gay Eclipse rum

½ ounce Stroh 160-proof rum

½ ounce amaretto

½ ounce lime juice

½ ounce ginger syrup

2 drops orange flower water

2 ounces POG (passion-orange-guava juice)

Build over ice in an 14-ounce squall glass, then pour into a cocktail shaker.

Without shaking, re-pour into the glass. Serve without garnish.

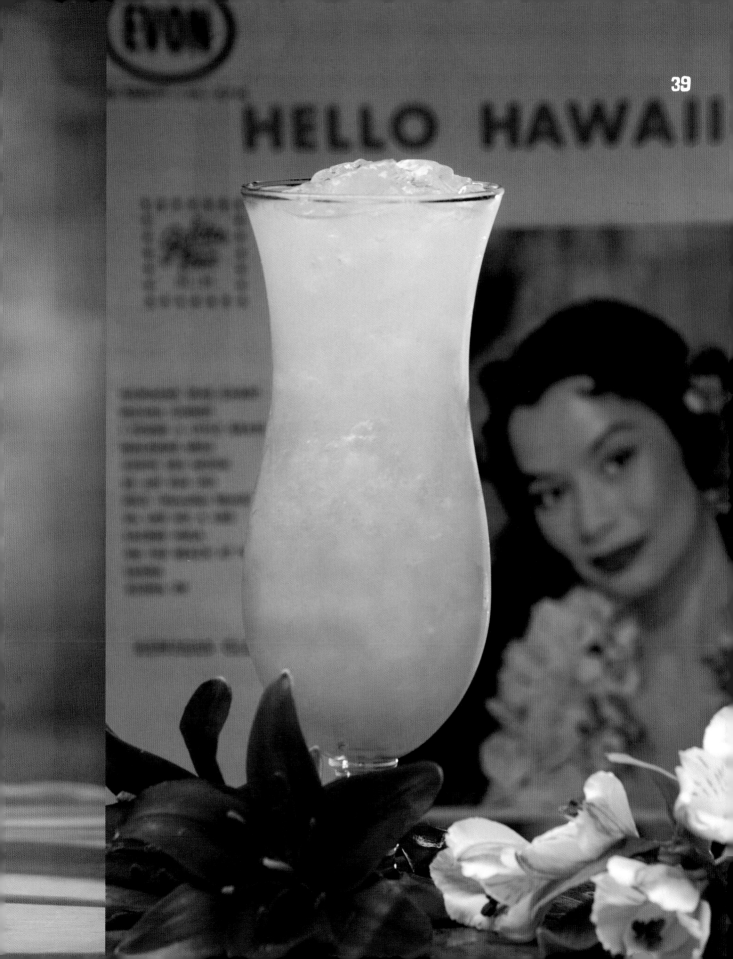

COCKEYED CASTAWAY

A supercharged orange flavor rush. This drink is appropriately named, so be careful not to flip your lid or forget your way home.

1 ounce Bacardi O orange rum

½ ounce Wray & Nephew White
 Overproof Rum

½ ounce Cointreau

Dash of orange bitters

1 ounce orange juice

2 ounces Rockstar Recovery Orange
 energy drink

Sprig of mint for garnish

Build over ice in a 10-ounce pilsner glass, then pour into a cocktail shaker.
Re-pour into the glass.
Serve garnished with mint.

COCO THE NUT

A refreshing jumble of flavors with a hint of nut, just like the crazy neighbor lady the drink is named for.

½ ounce Wray & Nephew White Overproof Rum

½ ounce macadamia nut liqueur

¼ ounce Tuaca

¼ ounce amaretto

½ ounce Coco Lopez

2 ounces papaya nectar

½ ounce Whaler's Original Dark Rum

Toasted coconut for garnish

Combine all ingredients except the Whaler's over ice in a 14-ounce squall glass, then pour into a cocktail shaker. Shake well, then re-pour into the glass.

Float the Whaler's on top, then serve garnished with toasted coconut.

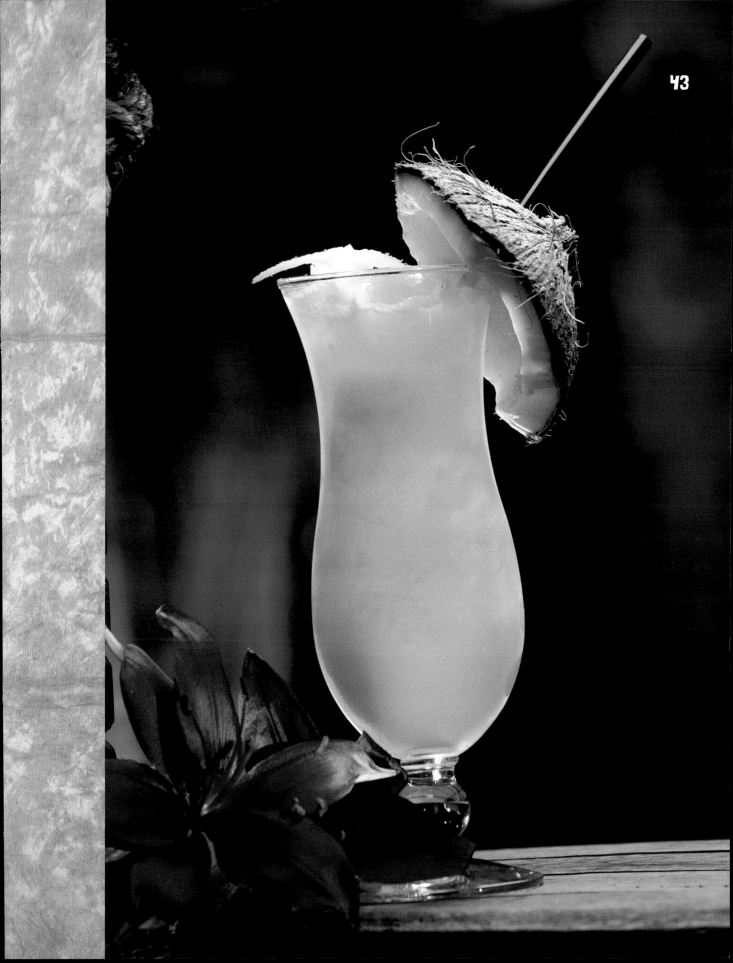

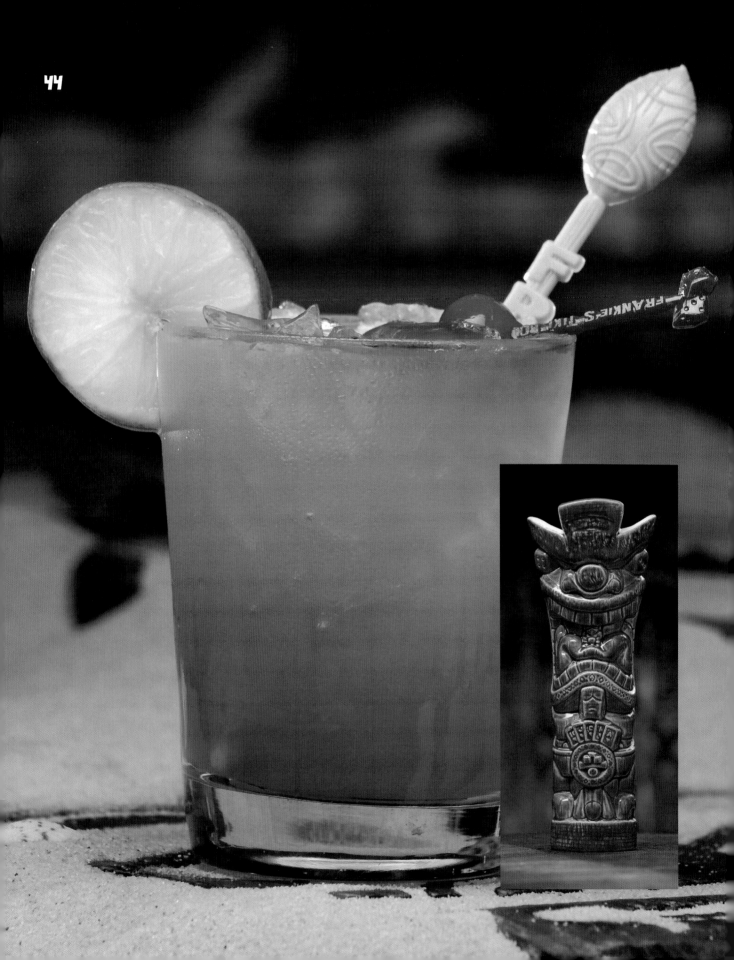

CRAZY AL'S HIGH ROLLER

This drink was created for Frankie's first anniversary and the Crazy Al-designed limited-edition tiki mug commemorating the occasion. It's a refreshing buzz with just enough kick to make you want to press your bets.

1 ounce Pyrat XO rum

½ ounce Cherry Heering

¾ ounce Tanqueray Rangpur gin

3 ounces guava nectar

1 ounce papaya nectar

1 ounce sweet and sour

½ ounce falernum

Dash Angostura bitters

Splash club soda

Lime wheel, for garnish

Cherry, for garnish

Build over ice in a 14-ounce double-old-fashioned glass (or the commemorative tiki mug if you are lucky enough to own one), then pour contents into a cocktail shaker.

Without shaking, re-pour into the glass.

Serve garnished with a lime wheel and a cherry.

DEMON RHUMBA

💀💀💀💀

A high-voltage orange jolt that will exorcise your demons. Drink two and they will come back double.

½ ounces Bacardi O orange rum

½ ounce Cointreau

½ ounce Hana Bay 151-proof rum

¼ ounce lime juice

1 dash orange bitters

1 ounce sweet and sour

2 ounces Fanta orange soda

Mint leaves for garnish

Build over ice in a 15-ounce bamboo glass, then pour contents into a cocktail shaker.
Without shaking, re-pour into the glass.
Serve garnished with mint leaves.

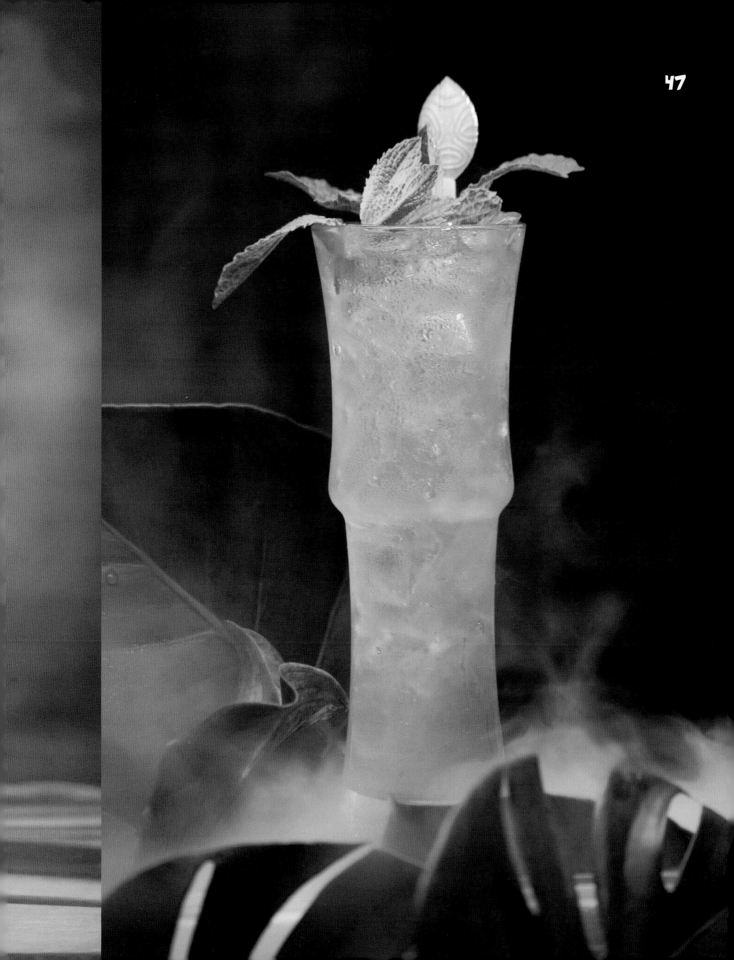

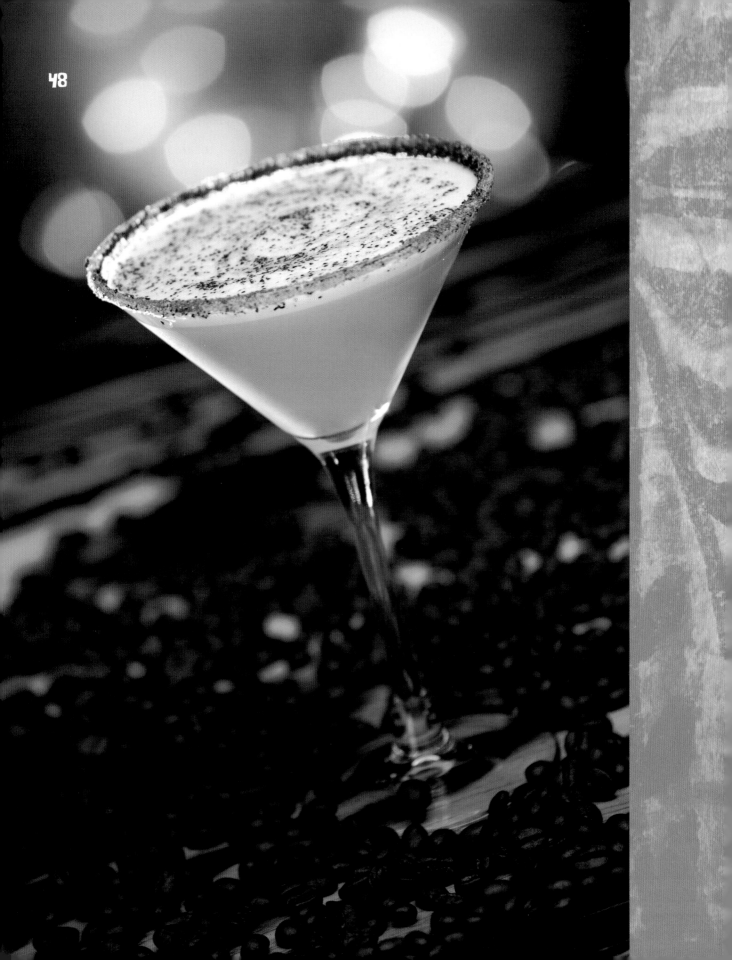

DIRTY LICK'NS

This lip-smacking favorite hits like a quick swat on the rear—though after a couple you might want to spank back.

½ ounce simple syrup

1 tablespoon dry ground Kona coffee

1 tablespoon granulated sugar

1½ ounces Whaler's Vanille rum

½ ounce macadamia nut liqueur

½ ounce Kahlua

2 ounces milk

 Moisten the rim of a chilled 8-ounce martini glass with simple syrup, then dip into a mixture of the coffee and sugar.

 In a cocktail shaker with ice, combine the remaining liquids. Shake well and strain into the martini glass.

 Serve garnished with a sprinkle of the remaining coffee and sugar.

DON Q. SACK

A drink for everyman, if that man is man enough to drink it. Goes down so smooth you will be singing in high fidelity.

2 ounces Don Q Gran Anejo rum

1 ounce Dry Sack medium dry sherry

½ ounce Grand Marnier

½ ounce orgeat syrup

2 ounces sweet and sour

2 ounces guava nectar

Lime wheel for garnish

Cherry for garnish

Build over ice in a 14-ounce double-old-fashioned glass and pour contents into a cocktail shaker.

Without shaking, re-pour contents into the glass. Serve garnished with lime wheel and a cherry.

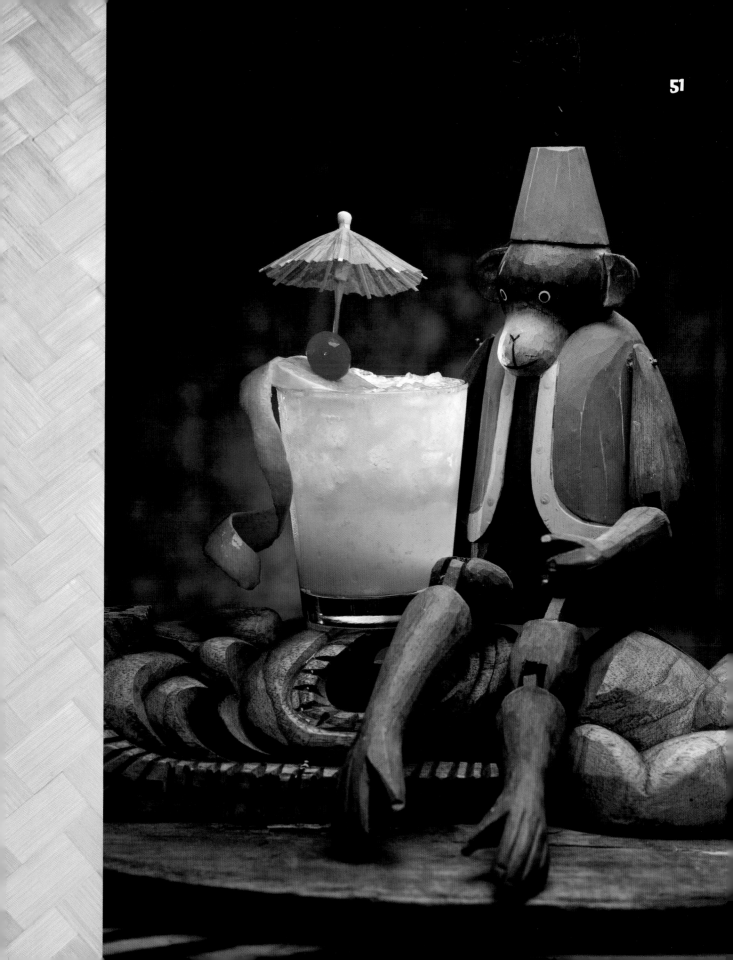

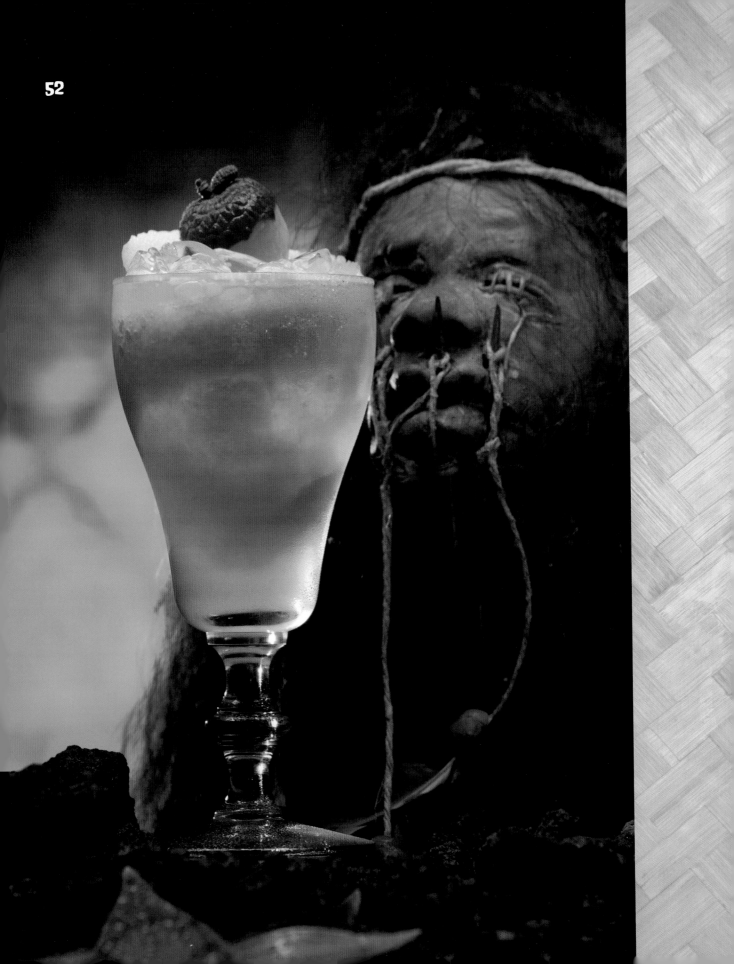

DR. NO

☠☠☠

Savagely sophisticated. Just one sip of this spicy delight will turn any no into an immediate YES.

2 ounces Macallan 12-year-old scotch

1 ounce Thatcher's Apple Spice Ginger liqueur

½ ounce five-spice syrup

2 drops orange bitters

2 ounces pear nectar

2 ounces soursop juice

Lemon zest for garnish

Lychee nut for garnish

Combine ingredients over ice in an 8-ounce Irish coffee glass.
Serve garnished with lemon zest and a lychee nut.

DRUNK MONK

A refreshingly unique flavor mosaic. Just one sip and you will be bowing to the god Frankie.

1 ounce Old Monk rum

½ ounce Appleton white rum

¼ ounce St. Elizabeth Allspice Dram

½ ounce date syrup

2 ounces milk

Grated nutmeg for garnish

Build over ice in an 11-ounce chimney glass, then pour into a cocktail shaker.
Shake, then re-pour into the glass.
Serve garnished with grated nutmeg.

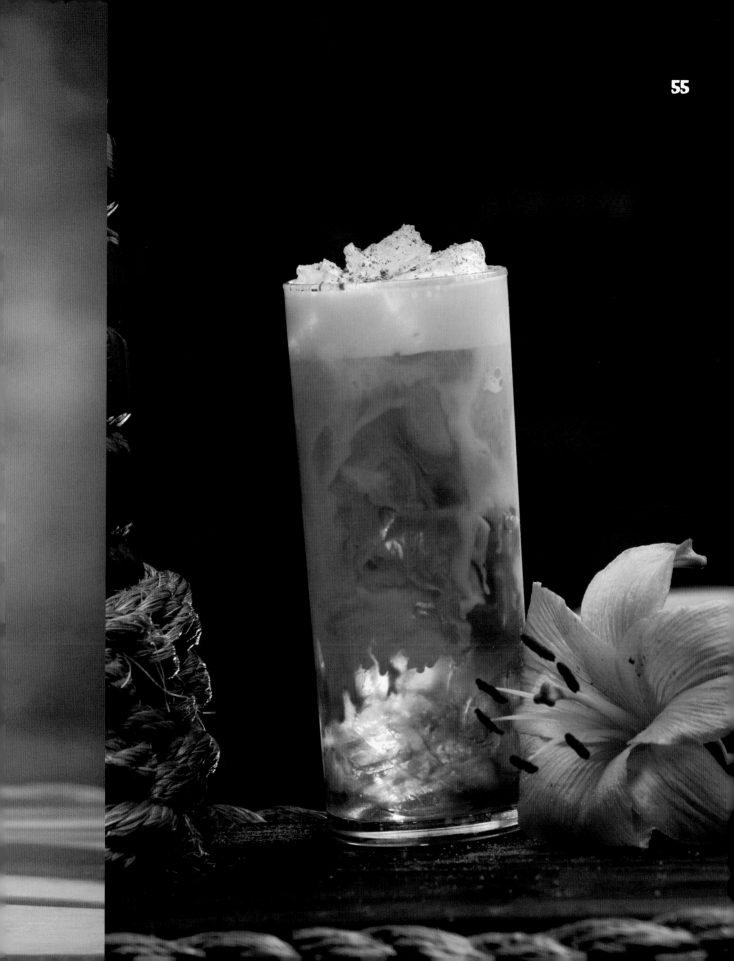

FINK BOMB

Don't be fooled by this mellow blend of coconut, melon and pineapple. The Fink Bomb will kick your ass.

1 ounce Cruzan Coconut Rum

1 ounce Midori melon liqueur

3 ounces pineapple juice

½ ounce Stroh 160-proof rum

 Fill a 14-ounce double-old-fashioned glass with ice, then add, in order, coconut rum, melon liqueur and pineapple juice.
 Float Stroh rum on top.
 Serve without garnish.

FIVE $ SHAKE

☠ ☠ ☠ ☠

This iron fist in a velvet glove will put the shimmy in your shake.

1½ ounces Knob Creek bourbon

1 ounce Koloa dark rum

1 ounce Whaler's Vanille rum

2 ounces milk

¼ ounce Malmsey Madeira wine

1 ounce dulce de leche (divided use)

Pinch red Alaea salt

Orange wedge for garnish

 Combine bourbon, rums, milk and ½ ounce dulce de leche over ice in a cocktail shaker. Shake vigorously. Pour the wine into a chilled 10-ounce pilsner glass, then add the contents of the cocktail shaker.
 Sprinkle salt over the top, then drizzle with the remaining dulce de leche.
 Serve garnished with an orange wedge.

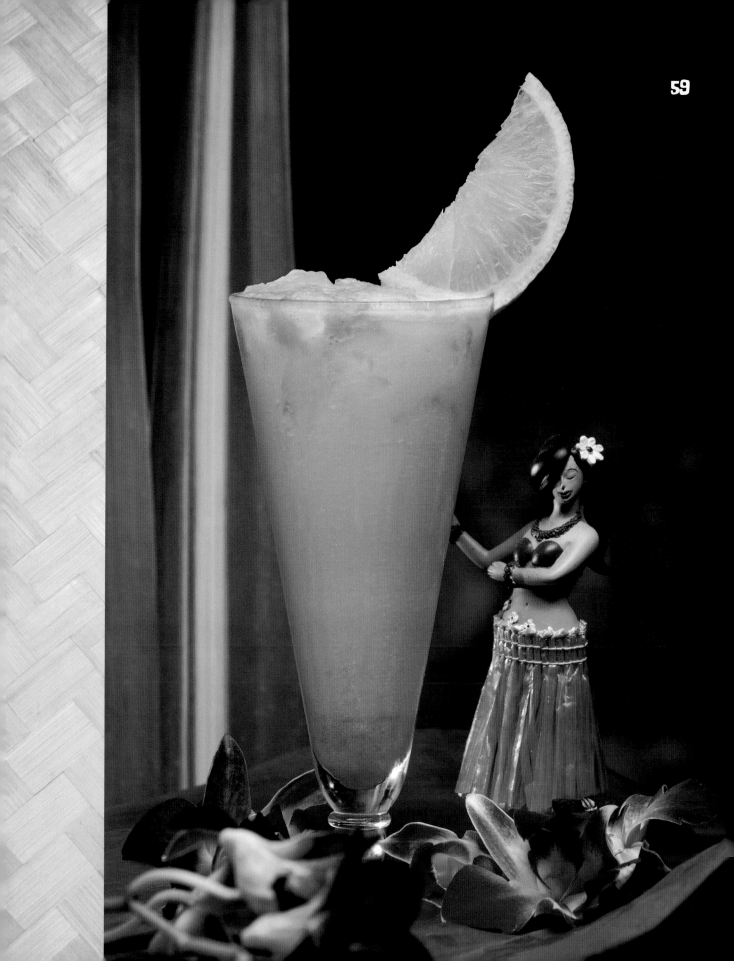

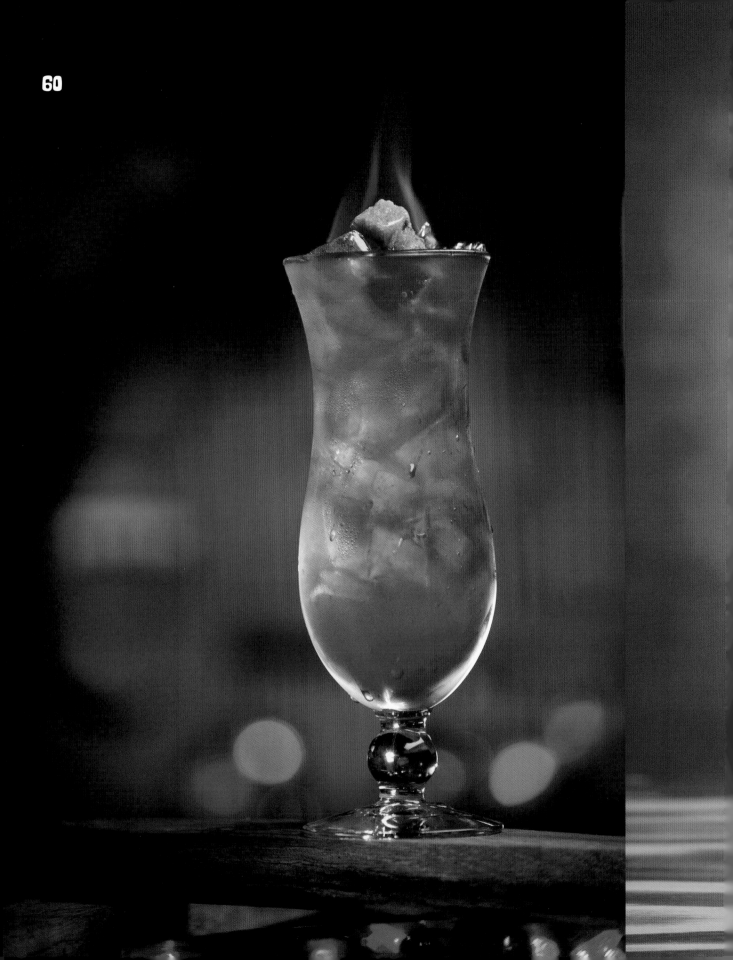

FIVE-O FIREBALL

Blast off for Cloud Nine with this high-octane infusion of rums and liqueurs. But be careful not to flame out upon re-entry.

1 ounce Lemon Hart 151-proof rum

1 ounce Myers's Platinum rum

½ ounce Appleton Special gold rum

¾ ounce Chambord

½ ounce Cointreau

½ ounce vanilla syrup

½ ounce lime juice

Dash of orange bitters

2 ounces club soda

1 ounce 7Up

½ ounce Stroh 160-proof rum

Sugar cube

Combine all ingredients except Stroh and sugar cube in a 14-ounce squall glass with ice, then pour contents into a cocktail shaker.

Without shaking, re-pour into the glass.

Soak the sugar cube in the Stroh rum, then place on top of the drink. Light the sugar cube and then serve.

GINJA NINJA

💀 💀 💀

A ginger-smacked thirst quencher with a vanilla kick. The perfect relaxer to unwind with before the real party gets started.

1 ounce Whaler's Vanille rum

½ ounce King's Ginger liqueur

½ ounce lime juice

¼ ounce passion fruit syrup

¼ ounce vanilla syrup

2 ounces ginger beer

Lime wheel for garnish

 Build over ice in a 10-ounce pilsner glass, then pour contents into a cocktail shaker.

Without shaking, re-pour into the glass.
Serve garnished with a lime wheel.

GON TIKI

💀 💀 💀

A brisk vagabond refresher for the pit stops on that tiki road trip you've been meaning to take. Don't drink too many, or you'll never make it out of Frankie's.

1 ounce Cruzan Aged Gold rum

½ ounce orange Curacao

½ ounce lime juice

Dash of Angostura bitters

2 ounces POG (passion-orange-guava juice)

2 ounces club soda

½ ounce Chambord

Orange wheel and cherry for garnish

Combine all ingredients except Chambord over ice in a 14-ounce double-old-fashioned glass, then pour contents into a cocktail shaker. Shake well, then re-pour the contents into the glass. Add Chambord, allowing it to settle to the bottom. Serve garnished with an orange wheel and a cherry.

GREEN GASSER

This revved-up neon burst will knock you off the barstool, then make you get up and beg for more.

1 ounce Cruzan Citrus Rum

1 ounce Midori melon liqueur

½ ounce Hana Bay 151-proof rum

1 ounce Rockstar energy drink

1 ounce sweet and sour

2 ounces pineapple juice

Pineapple for garnish

Build over ice in a 17-ounce snifter, then pour contents into a cocktail shaker.

Without shaking, re-pour into the glass. Serve garnished with pineapple.

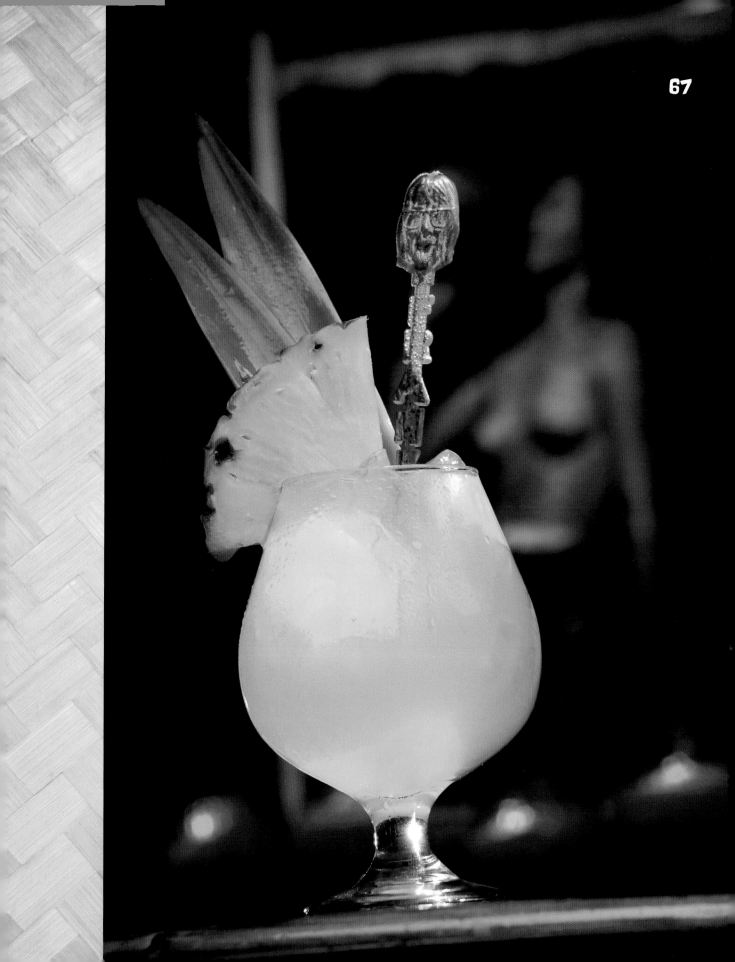

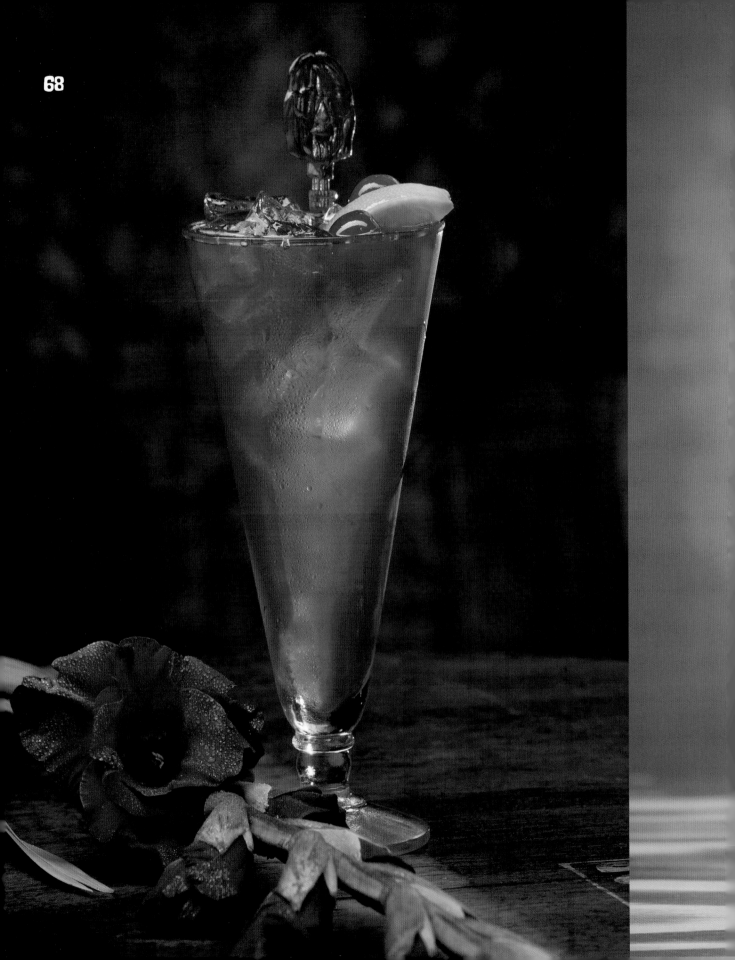

HANGA ROA HOLD UP

💀 💀 💀

Just like its namesake village on Easter Island, this tangy refresher offers the perfect escape from the hustle and bustle.

1 ounce Whaler's Original Dark Rum

½ ounce maraschino liqueur

½ ounce lime juice

1 ounce club soda

2 ounces Hawaiian Sun Luau Punch

Cherries for garnish

Lime wedge for garnish

Build over ice in a 10-ounce pilsner glass, then pour into a cocktail shaker.
Without shaking, re-pour into the glass.
Serve garnished with cherries and a lime wedge.

HIGGINS

💀 💀 💀

As brisk as it is smooth, this cocktail is the ultimate in island sophistication.

2½ ounces Hendricks gin

1½ ounces Theia Jasmine Liqueur

1½ tablespoons honey

3 drops rose water

Honeycomb for garnish

Combine all ingredients in a mixing glass with no ice, then stir with a bar spoon until the honey blends evenly with the liquid. Add ice and continue to stir until chilled.

Strain into a chilled 8-ounce martini glass.

Serve garnished with a piece of honeycomb.

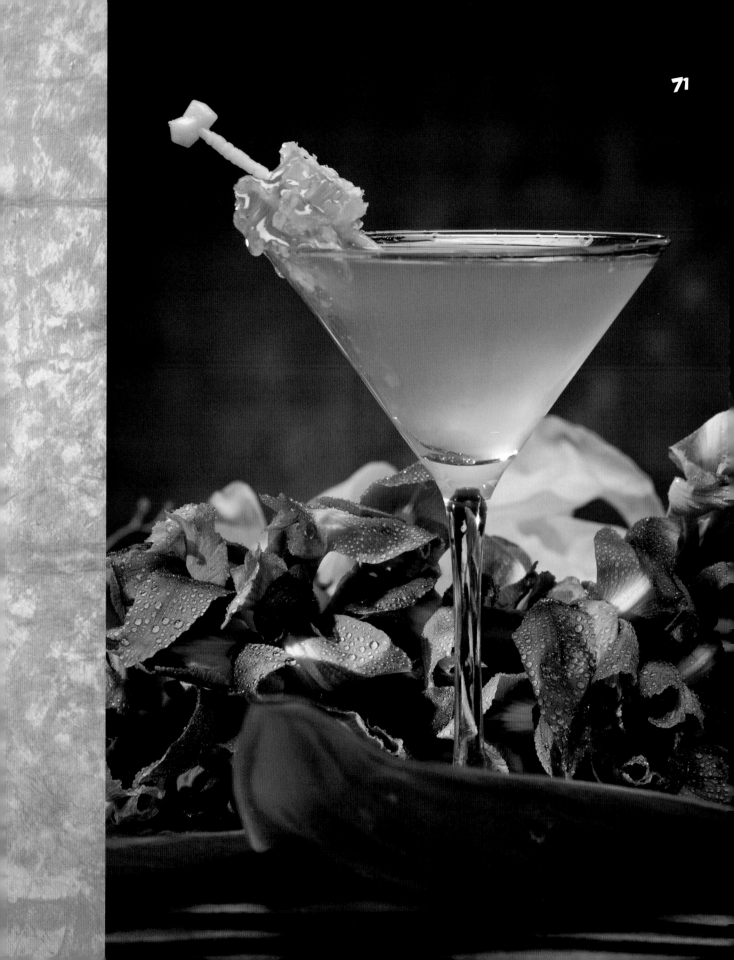

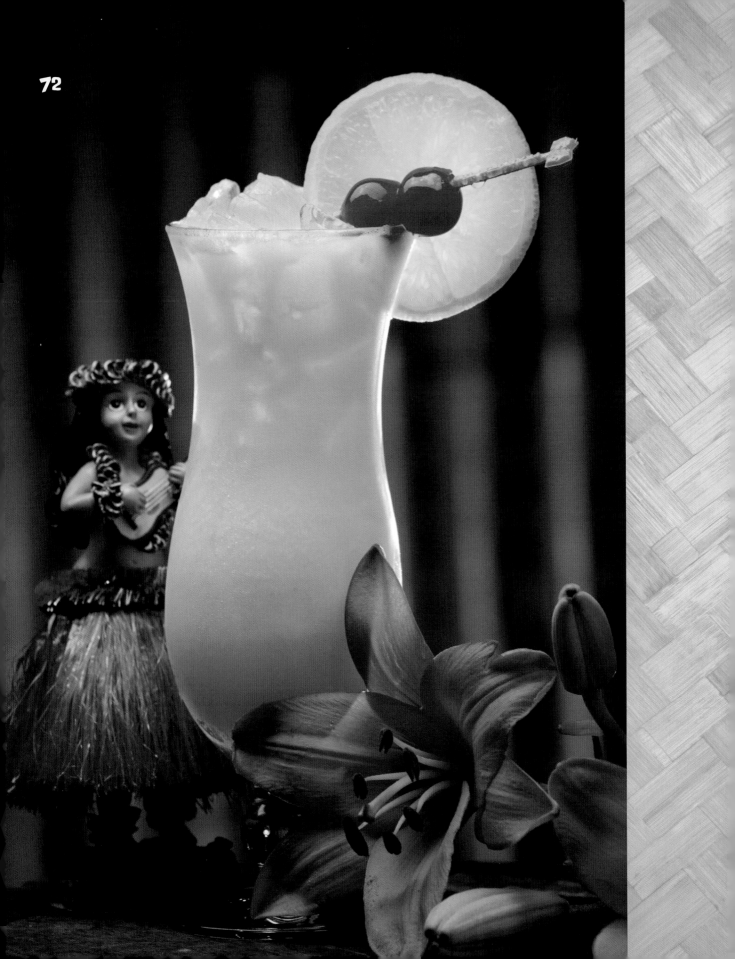

HULABILLY HONEY

☠☠☠☠

A favorite of the Hula Girls who coined the phrase, this coconut-gyrating spike of flavors is guaranteed to get those grass skirts shaking.

1 ounce Mount Gay Eclipse rum

½ ounce Lemon Hart 151-proof rum

½ ounce falernum

1 ounce Coco Lopez

½ ounce honey syrup

2 dashes cherry bitters

3 ounces mango nectar

1 ounce orange juice

Cherries and orange wheel for garnish

Build over ice in a 14-ounce squall glass, then pour into a cocktail shaker.
Shake well, then re-pour into the squall glass.
Serve garnished with cherries and an orange wheel.

JONAS GRUMBY

This hale-and-hearty bracer is rumored to be the cause of the most famous shipwreck in the history of the Pacific.

1 ounce Sailor Jerry Spiced Rum

½ ounce Cruzan Mango Rum

½ ounce apricot brandy

¼ ounce Cruzan Black Strap Rum

2 ounces apricot/mango nectar

Splash of club soda

Fill a 14-ounce double-old-fashioned glass with ice, then add rums, brandy and nectar. Fill to the top with club soda.

Pour contents into a cocktail shaker. Without shaking, re-pour into the glass.

Serve without garnish.

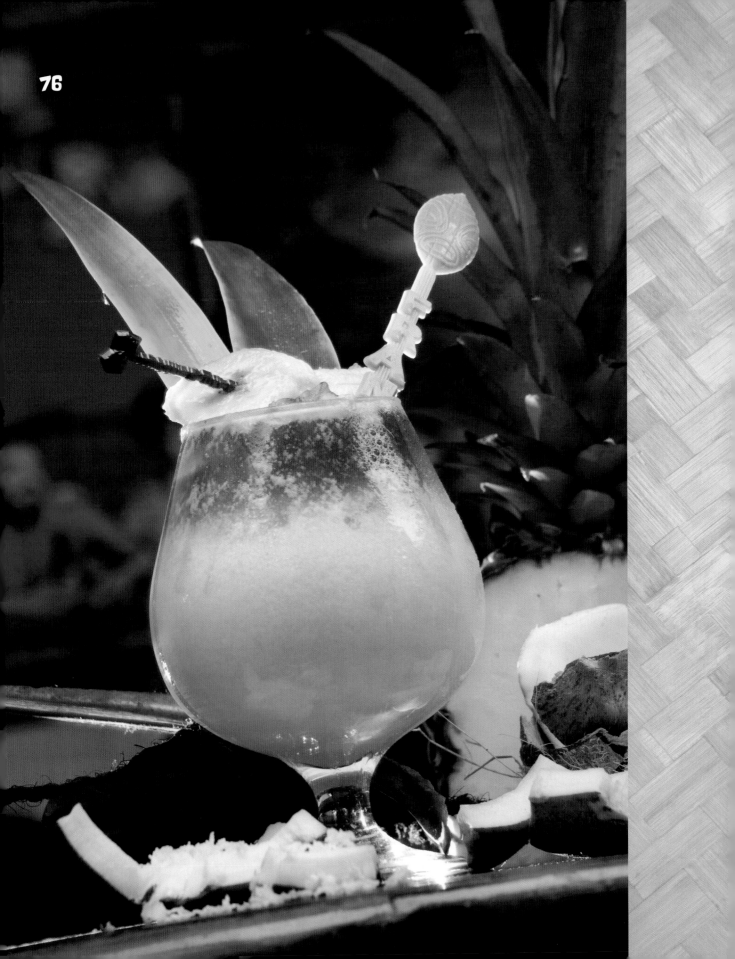

KAHIKI KAI

☠ ☠ ☠

This creamy delight of pure island freshness provides the perfect escape to the perfect state of mind.

1 ounce Cruzan Coconut Rum

1 ounce creme de banana

1 ounce Coco Lopez

3 ounces pineapple juice

½ ounce Whaler's Original Dark Rum

Sliced banana for garnish

Fill a 17-ounce snifter with ice, then add coconut rum, creme de banana, Coco Lopez and pineapple juice.

Pour contents into a cocktail shaker. Shake vigorously, then re-pour into the snifter.

Float Whaler's rum on top. Served garnished with sliced banana.

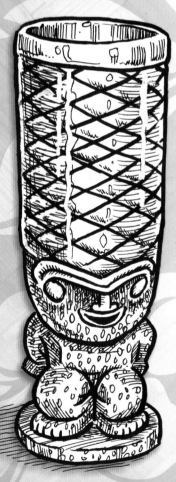

KANAKA KISS

💀💀💀

Inspired by the original Hawaiian Islanders, this light kiss of refreshment will transport you to paradise.

1 ounce Bacardi Limon

½ ounce peach schnapps

2 ounces pineapple juice

¼ ounce grenadine

Lemon wedge

Combine Bacardi, schnapps and pineapple juice in a cocktail shaker. Shake well then strain into a chilled 8-ounce martini glass. Drizzle the grenadine down the inside of the glass

Float the juice of the lemon wedge on top of the drink (careful not to drop in the rind).

Serve without garnish.

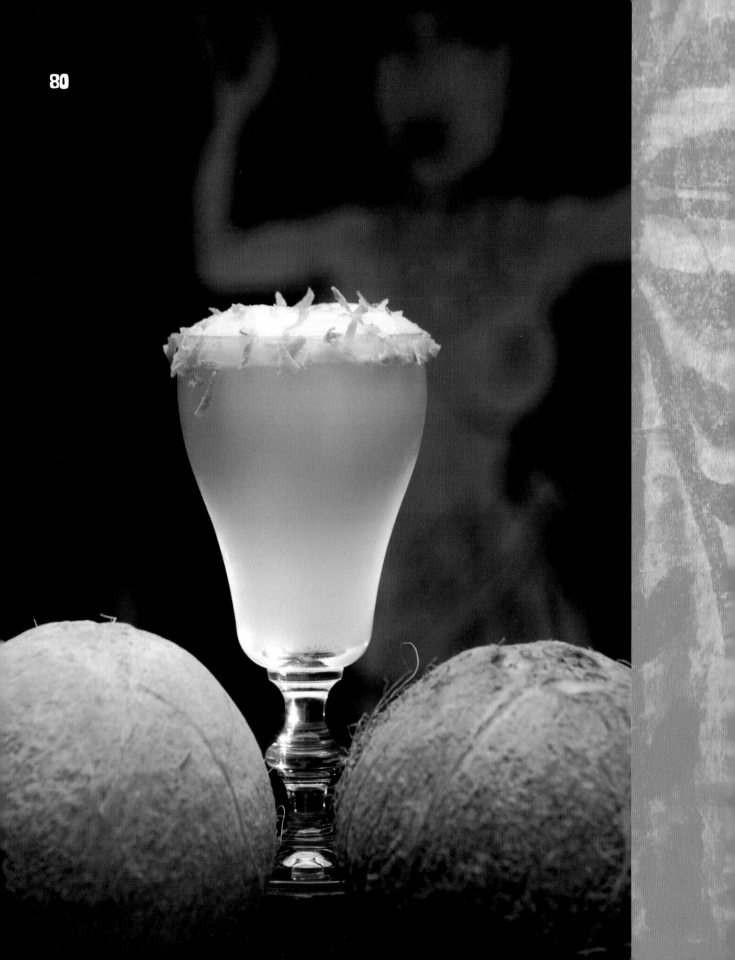

KAPAKAHI

A hint of spice gives this smooth sipper an exotic kick, but it's the toasted coconut and whipped cream that make fans refer to it as dessert in a glass.

½ ounce simple syrup

1 teaspoon toasted coconut, plus more for garnish

2 ounces Prichard's Key lime rum

1 ounce Whaler's Vanille rum

1 ounce Cruzan Pineapple Rum

2 ounces pineapple juice

1 ounce lime juice

¼ ounce five-spice syrup

Dollop of whipped cream

Moisten the rim of a chilled 8-ounce Irish coffee glass with simple syrup, then dip in the toasted coconut. In a cocktail shaker with ice, add the remaining ingredients (including the whipped cream). Shake well and strain into the martini glass. Serve garnished with a sprinkle of toasted coconut.

LAVA LETCH

A lecherous concoction that will turn the most proper gentleman into a raving maniac. Lock up your daughters.

1 ounce Mount Gay Eclipse rum

1 ounce Chambord

½ ounce Christian Brothers brandy

½ ounce lime juice

Dash Angostura bitters

2 ounces ginger beer

Raspberries for garnish

Lime wheel for garnish

Build over ice in a 17-ounce snifter. Serve garnished with raspberries and a lime wheel.

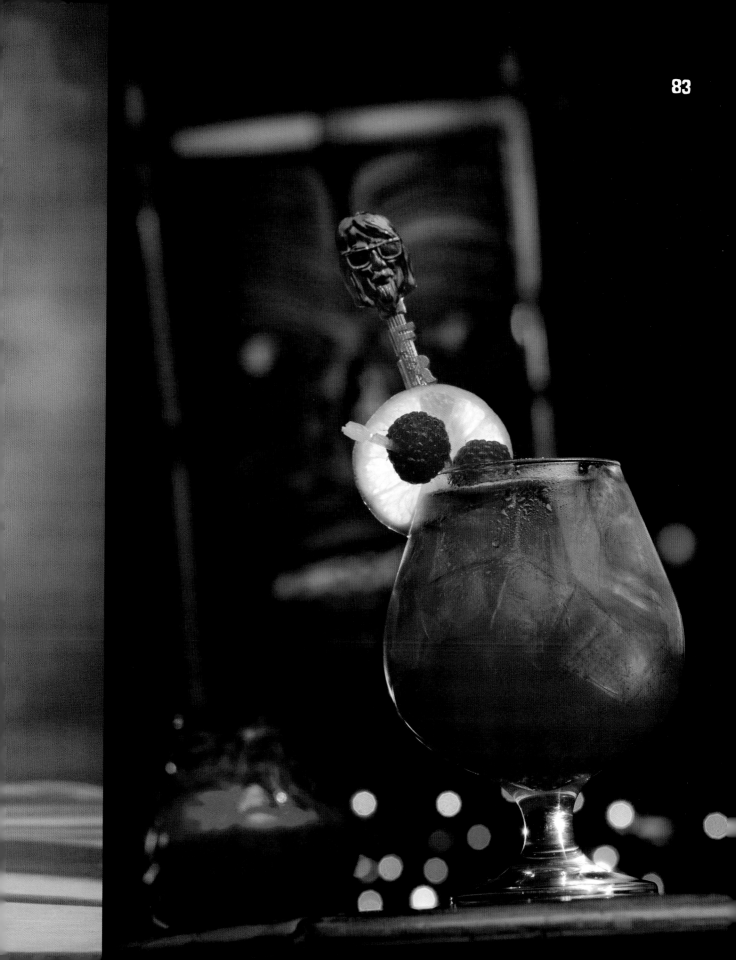

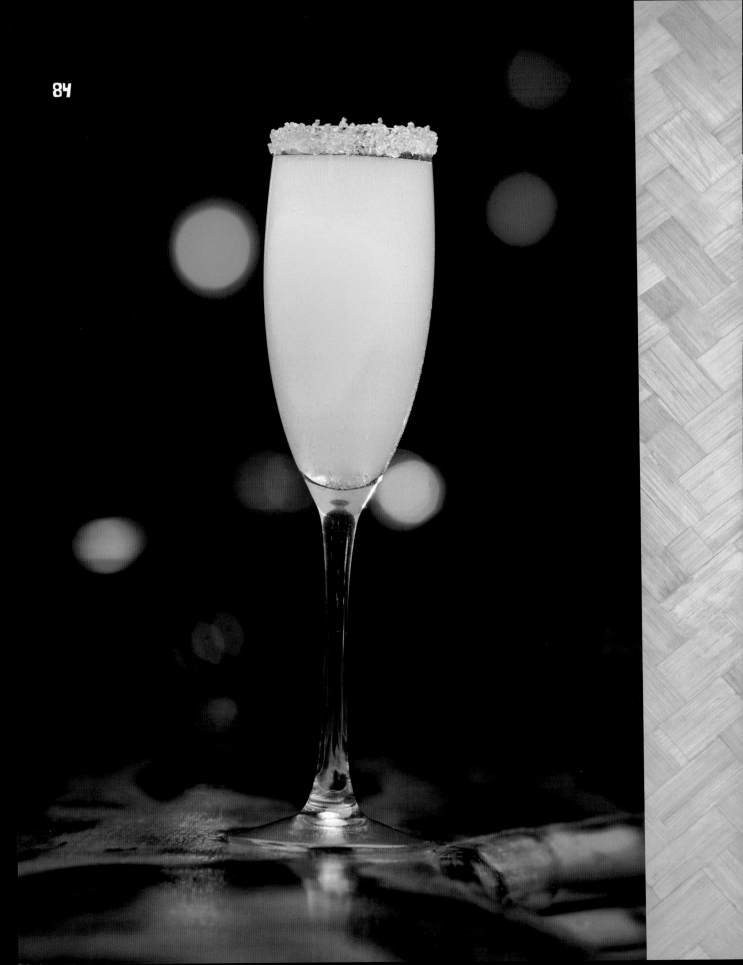

LOVEY'S REVENGE

💀 💀 💀

If living well is the best revenge, then sipping this bubbly elixir on a desert island is the sweetest payback of all.

½ ounce lime juice

1 teaspoon turbinado sugar

1 ounce Cruzan Pineapple Rum

1 ounce creme de banana

½ ounce orange juice

5 ounces Champagne

 Moisten the rim of an 8-ounce flute with a little lime juice and rim with the sugar.

 Over ice in a cocktail shaker, combine the rum, creme de banana and orange juice. Shake well and strain into the flute, then fill to the top with Champagne.

 Serve without garnish.

LUCKY LEROY

💀 💀 💀

This drink was created for Frankie's fourth anniversary and the Leroy Schmaltz-designed limited-edition tiki mug commemorating the occasion. A tangy refresher in honor of the revered godfather of all tiki carvers. After two, you just might find the fourth ace.

1 ounce Appleton White rum

½ ounce Hana Bay 151-proof rum

½ ounce apricot brandy

½ ounce Van Der Hum liqueur

¼ ounce St. Elizabeth Allspice Dram

½ ounce ginger syrup

½ ounce lemon juice

Dash of Angostura bitters

2 ounces club soda

½ ounce Whaler's Original Dark Rum

Twisted orange wheel for garnish

Build all ingredients except the Whaler's over ice in a 15-ounce bamboo glass (or the commemorative tiki mug if you are lucky enough to own one). Then pour into a cocktail shaker.

Without shaking, re-pour into the glass. Float the Whaler's rum on top.

Serve garnished with a twisted orange wheel.

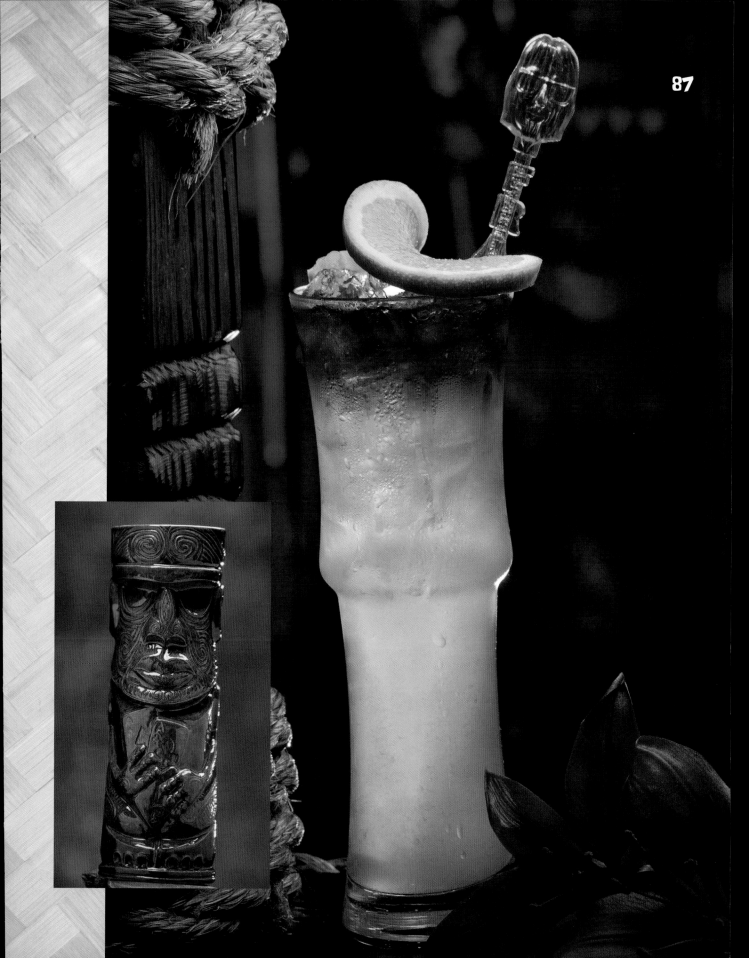

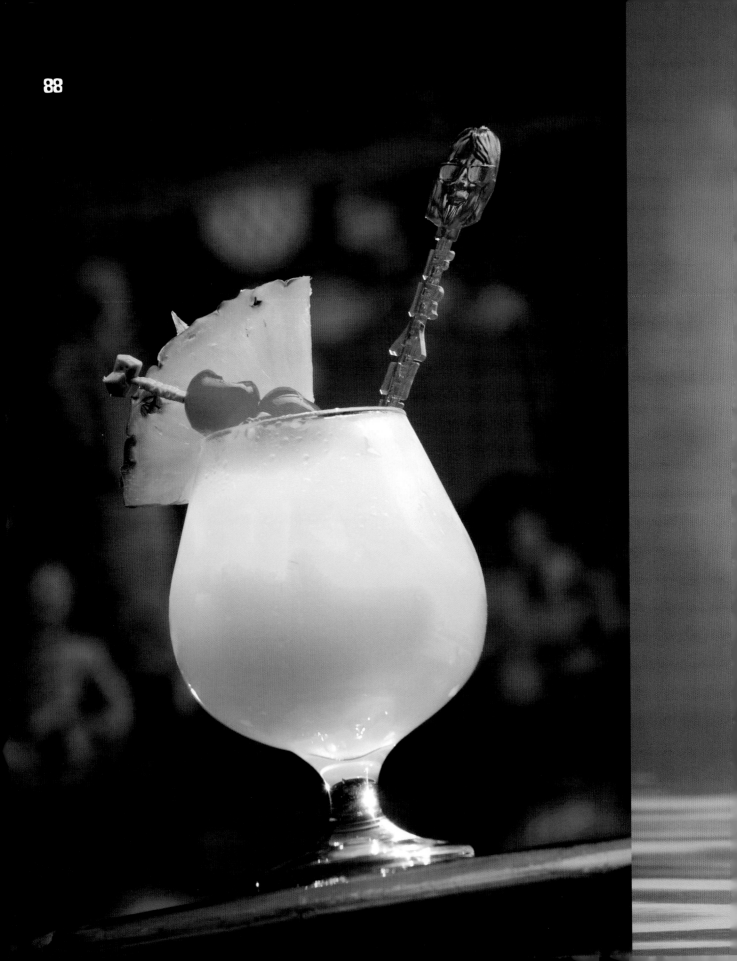

MALEKULA

This glowing island elixir is as refreshing as a day at the beach.

¾ ounce Cruzan coconut rum

¾ ounce Tuaca

¾ ounce Midori melon liqueur

2 ounces pineapple juice

2 ounces orange juice

Splash of 7Up

Pineapple and cherries for garnish

Build over ice in a 17-ounce snifter, then pour contents into a cocktail shaker.
Without shaking, re-pour into the snifter.
Serve garnished with pineapple and cherries.

MU'U MU'U MARY

This tiki-twisted Bloody Mary will turn even the grayest skies blue. Its mosaic of exotic flavors will save your soul.

The mix:

2 cups tomato juice

2 tablespoons soy sauce

2 tablespoons Worcestershire

2 tablespoons sriracha hot sauce

1 tablespoon pickled ginger liquid

¼ teaspoon ground ginger

¼ teaspoon garlic powder

¼ teaspoon ichimi togarashi chili powder

Juice of a whole lemon

Stir to mix ingredients together in a pitcher, then set aside.

The drink:

1 tablespoon lime juice

1 teaspoon red Alaea salt

1 teaspoon black lava sea salt

2 ounces vodka

4 ounces Mu'u Mu'u Mary mix

Grilled stick of Spam for garnish

Hard-cooked quail egg for garnish

Pickled ginger for garnish (optional)

Moisten the edge of a 14-ounce double-old-fashioned glass with the lime juice. Combine the two salts and then rim the glass; set it aside.

In a cocktail shaker with ice, combine the vodka and the mix. Shake well, then pour into the glass, careful not to dislodge salt from the rim. Add ice, if necessary, to fill.

Garnish with a grilled Spam stick and a hard-cooked quail egg on a pick (and add a slice or two of pickled ginger between them if you like).

Top with shredded nori (seaweed) and serve.

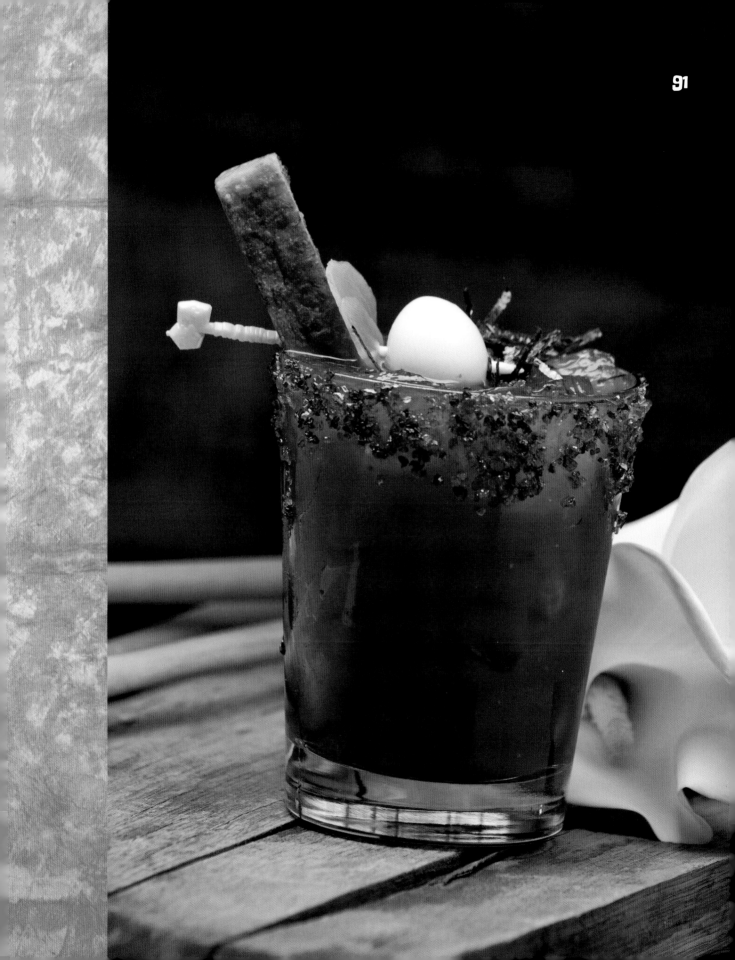

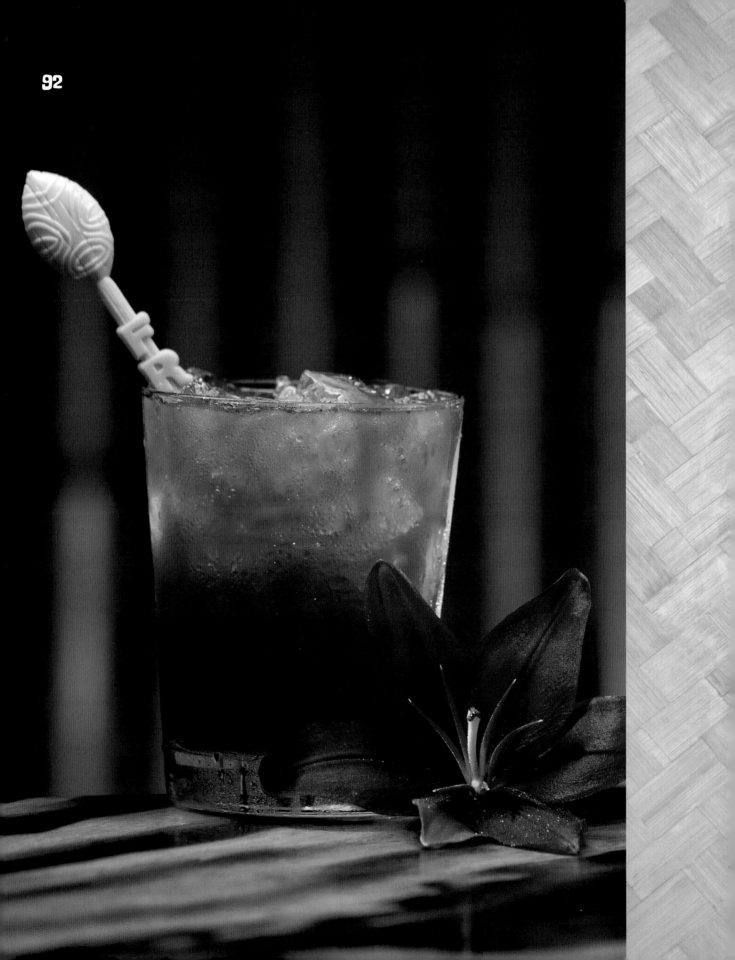

MURKY LAGOON

This no-frills bracer will have you seeing clearly in no time.

2 ounces Whaler's Original Dark
 Rum

½ ounce falernum

3 ounces guava nectar

Build over ice in a 14-ounce double-old-fashioned glass, then pour contents into a cocktail shaker.
Shake well, then re-pour into the glass.
Serve without garnish.

MUTINY

For those scalawags who refuse to drink rum. This perfect storm of flavor will keep you from walking the plank.

½ ounce vodka

½ ounce amaretto

½ ounce Midori melon liqueur

½ ounce Everclear

2 ounces cranberry juice cocktail

2 ounces club soda

1 ounce sweet and sour

Lime wheel for garnish

Cherry for garnish

Build over ice in a 14-ounce double-old-fashioned glass.
Serve garnished with a lime wheel and a cherry.

NAKALELE KNOCKOUT

☠ ☠ ☠ ☠ ☠

This tangy refresher pays tribute to the human sacrifices once offered to the infamous namesake blowhole on Maui. Drink one and count your blessings. Drink two and watch your step.

1 ounce Whaler's Original Dark Rum

1 ounce Lemon Hart 151-proof rum

½ ounce Batavia arrack liqueur

1 ounce hibiscus syrup

¾ ounce lime juice

Dash Angostura bitters

2 ounces club soda

Lime wheel for garnish

Fill a 14-ounce double-old-fashioned glass with ice, then add rums, liqueur, syrup, juice and bitters. Fill to the top with club soda.

Serve garnished with a lime wheel.

NINTH ISLAND

Las Vegas is often referred to as the ninth Hawaiian island. One swig from this stinging lava flow and you will understand why.

¼ ounce light rum

¼ ounce gold rum

¼ ounce vodka

¼ ounce Tanqueray Rangpur gin

¼ ounce triple sec

¼ ounce falernum

½ ounce sweet and sour

2 ounces pineapple juice

¼ ounce grenadine

½ ounce Whaler's Original Dark Rum

Lemon wheel for garnish

Fill a 14-ounce double-old-fashioned glass with ice, then add liquors, triple sec, syrup, sweet and sour and pineapple juice. Drizzle the grenadine down the inside of the glass. Float the Whaler's rum on the top. Serve garnished with a lemon wheel.

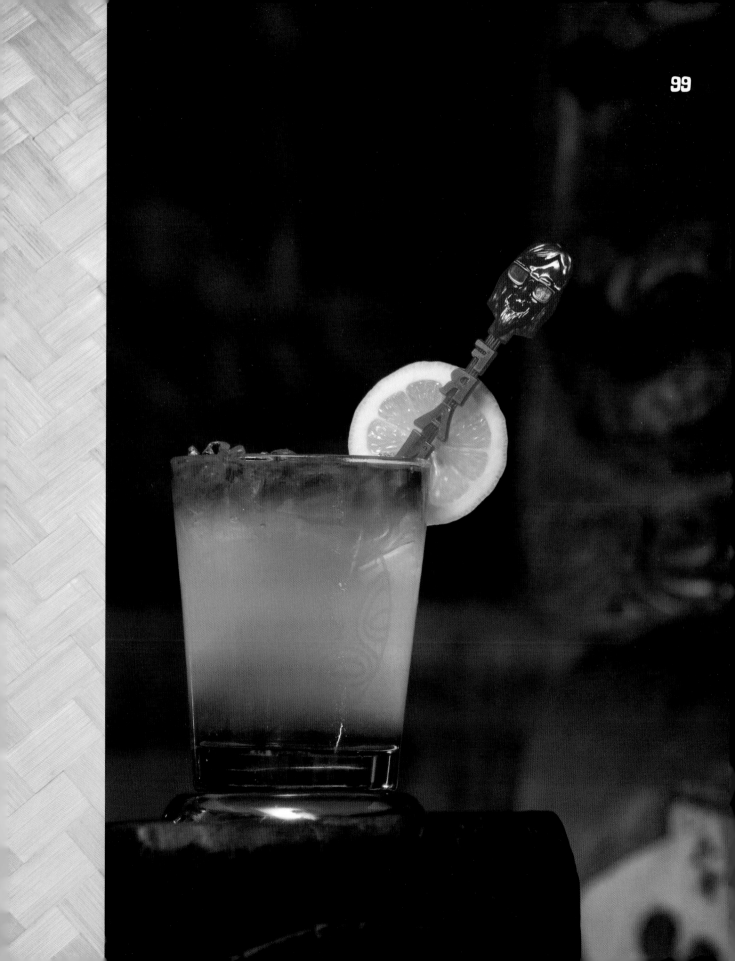

POLYNESIAN PILE DRIVER

💀 💀 💀 💀

A pink punch in the face guaranteed to send you off the deep end.

1 ounce Pyrat XO rum

½ ounce Cruzan pineapple rum

½ ounce Hana Bay 151-proof rum

1 ounce hibiscus syrup

½ ounce lime juice

Splash of club soda

Stick of sugar cane for garnish

 Fill a 14-ounce double-old-fashioned glass with ice, then add rums, hibiscus syrup and lime juice. Top with club soda.

 Pour contents into a cocktail shaker, then, without shaking, re-pour into the glass.

 Serve garnished with a sugar-cane stick.

PUXADO

A cornucopia of exotic flavors, this tangy refresher goes down smoothly. Maybe too smoothly.

1½ ounces Pitu Cachaca

1 ounce King's Ginger liqueur

½ ounce Cruzan Mango Rum

¼ ounce Chartreuse Green

Dash sweet vermouth

3 drops orange flower water

½ tablespoon honey

¼ cup fresh mango, peeled and cubed

2 ounces club soda

Shaved mango peel and a mango twist for garnish

 In an empty mixing glass, combine all ingredients except the club soda. Muddle until the mango is completely pulverized. Add ice and shake well. Strain the mixture into an 10-ounce pilsner glass and top with club soda. Serve garnished with shaved mango peel and a mango twist.

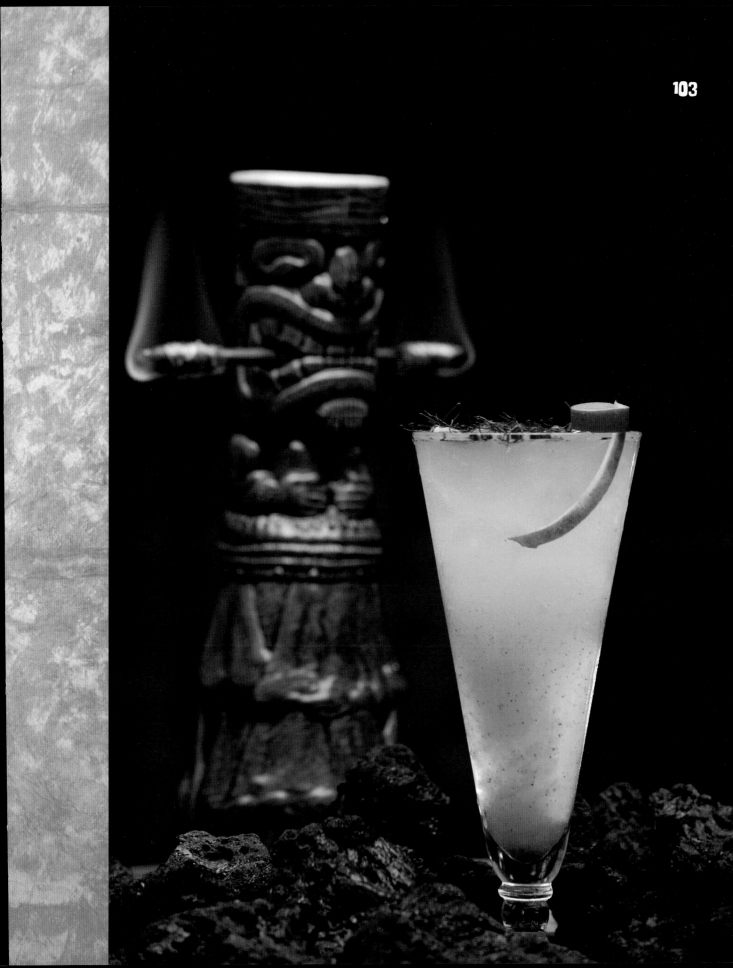

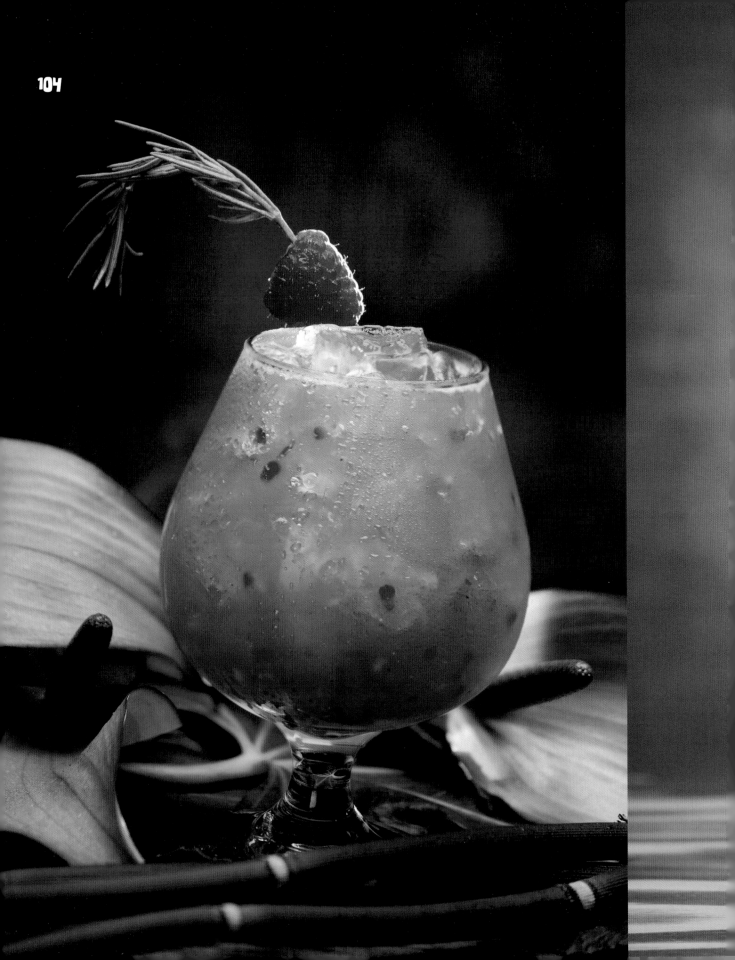

R & R

Raspberry and rosemary provide the spark for this refreshing elixir that will quickly have you on top of the world. Or under the table.

1½ ounces Tanqueray gin

1 ounce Flor De Cana 4-year-old white rum

½ ounce creme de cassis

½ ounce Bertina elderflower liqueur

6 raspberries, plus more for garnish

Pinch fresh ground pepper

2 ounces pear nectar

Sprig of rosemary

Place all ingredients except pear nectar and rosemary in a mixing glass. Add ice and shake until the raspberries break up.

Pour the contents into a 17-ounce snifter, then top with pear nectar.

Strip all of the rosemary leaves off the sprig except those on the very end, for an added essence of rosemary when stirring the drink. Spear a raspberry with the sprig and garnish the drink.

RUM RUM RUDOLPH

A jingly blend of flavors that will send you flying over the pole.

1 ounce Cruzan 9 Spiced Rum

1 ounce Hana Bay 151-proof rum

½ ounce cinnamon syrup

¼ ounce vanilla syrup

½ ounce Coco Lopez

Dash Angostura bitters

2 ounces orange juice

Ground nutmeg

Cherry for garnish

Build over ice in a 14-ounce double-old-fashioned glass,
then pour contents into a cocktail shaker. Shake well, then re-pour into
the glass.
Sprinkle nutmeg on top, then serve garnished with a cherry.

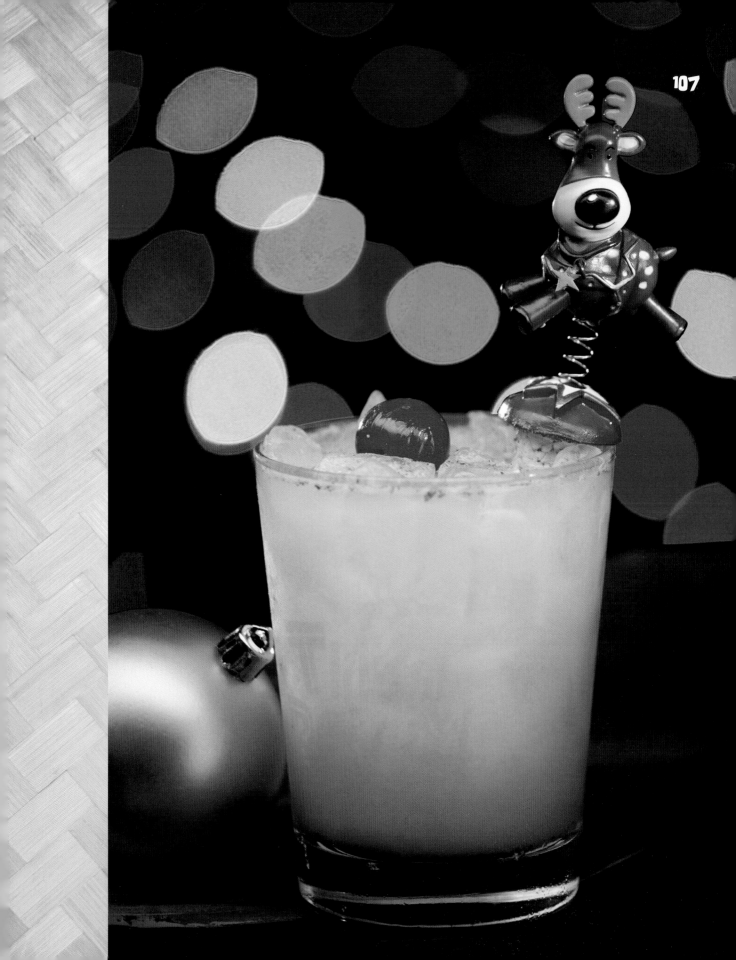

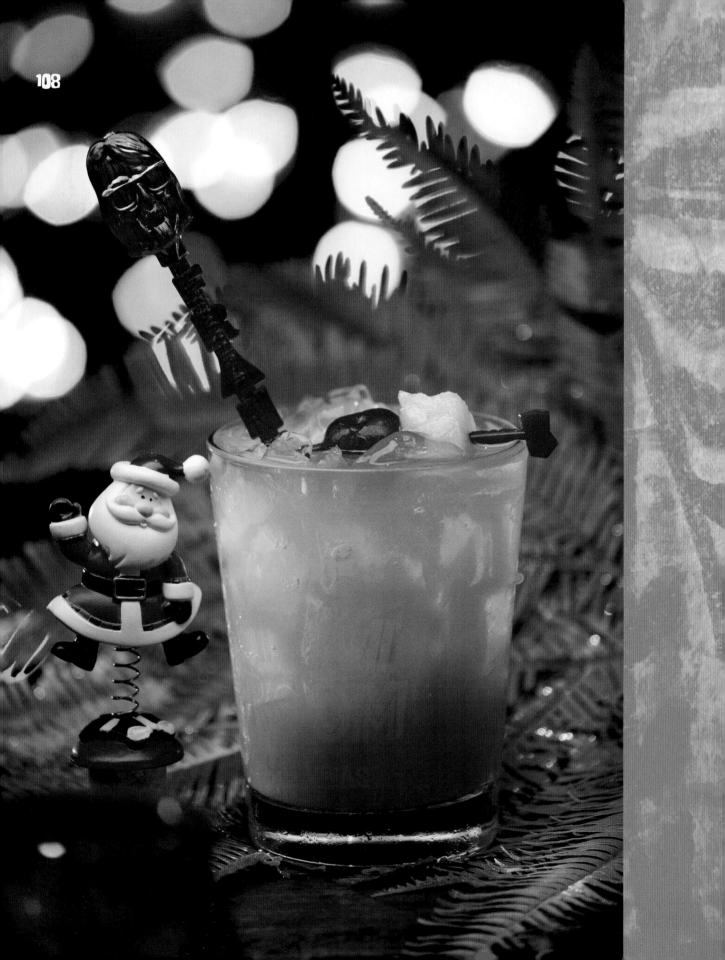

SANTALOHA

💀 💀 💀

Santa's favorite pit-stop punch is at the top of everyone's Christmas list.

1 ounce Cruzan 9 Spiced Rum

½ ounce Hana Bay 151-proof rum

½ ounce falernum

¼ ounce cinnamon syrup

½ ounce white grapefruit juice

2 ounces orange juice

2 ounces cranberry juice cocktail

Pineapple and cherry for garnish

 Build over ice in a 14-ounce double-old-fashioned glass, then pour contents into a cocktail shaker.
 Shake well, then re-pour into the glass.
 Serve garnished with pineapple and a cherry.

SAVAGE FLAME

This combustible eye-opener will make even the most gentle soul run amok.

1 ounce Oronoco rum

½ ounce Cointreau

¼ ounce St. Elizabeth Allspice Dram

1 ounce guava nectar

½ ounce ginger syrup

½ ounce lime juice

Dash of Angostura bitters

 Build over ice in a cocktail shaker. Shake, then strain into a 5-ounce coupe glass.
 Serve without garnish.

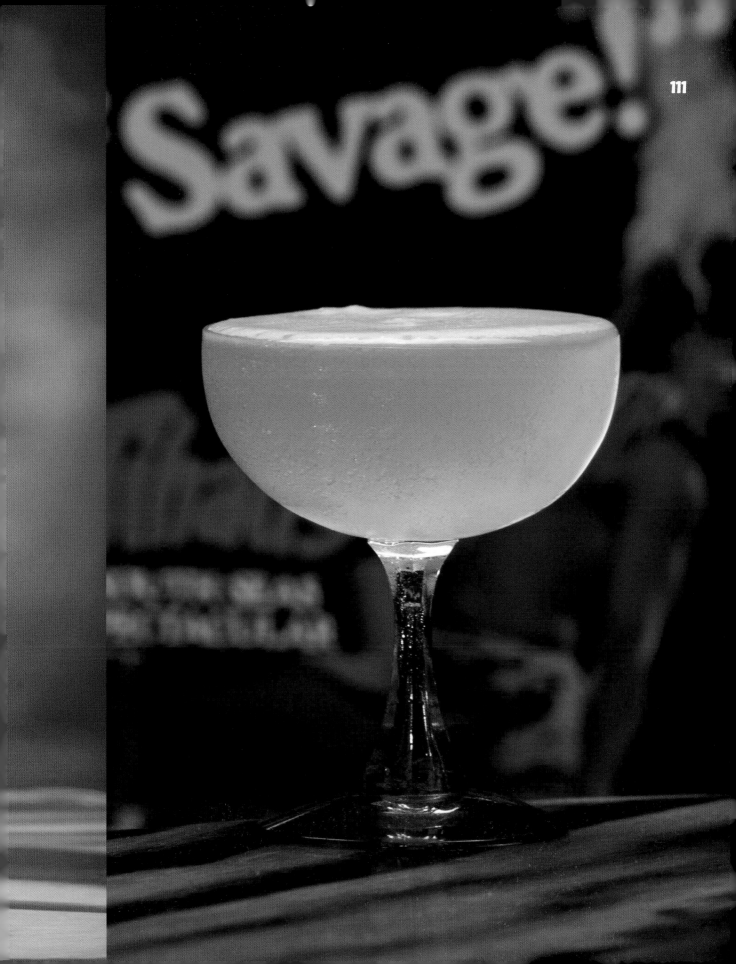

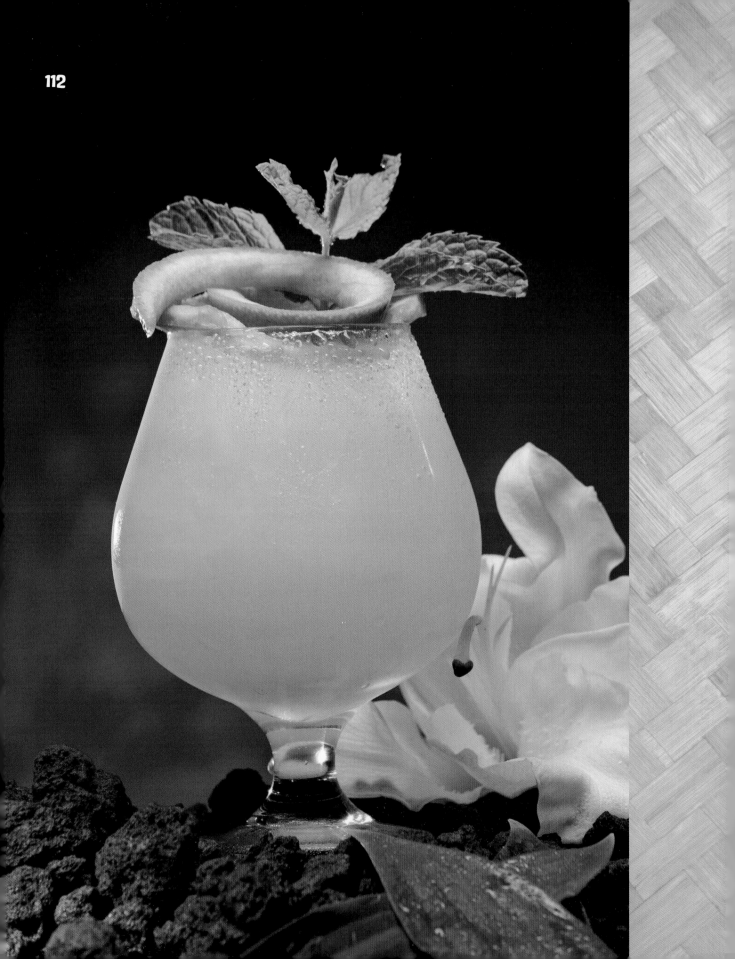

SCURVY

Does this brisk bracer cure it or cause it? Drink two and you will have the answer.

2 ounces Cruzan Citrus Rum

1½ ounces Cruzan Aged Light Rum

1 ounce Cruzan Coconut Rum

Dash Angostura bitters

2 ounces pineapple juice

2 ounces sweet and sour

¼ ounce Coco Lopez

Dash of simple syrup

5 lime wedges

6 mint leaves

Pinch of red Alaea salt

2 ounces club soda

2 ounces 7Up

Grapefruit peel and mint sprig for garnish

In a mixing glass, carefully muddle all ingredients except the club soda and 7Up. Add ice and shake well.

Strain into an ice-filled 17-ounce snifter, then top with equal parts club soda and 7Up.

Serve garnished with grapefruit peel and a sprig of mint.

SEA HAG
💀 💀 💀

A tangy thirst-quencher that will give you the magical power to make those around you disappear.

1½ ounces Cruzan Aged Dark Rum

½ ounce blackberry brandy

¼ ounce Cherry Heering

2 ounces guava nectar

2 ounces papaya nectar

Cherries for garnish

Build over ice in a 14-ounce double-old-fashioned glass, then pour contents into a cocktail shaker.
Without shaking, re-pour into glass.
Serve garnished with cherries.

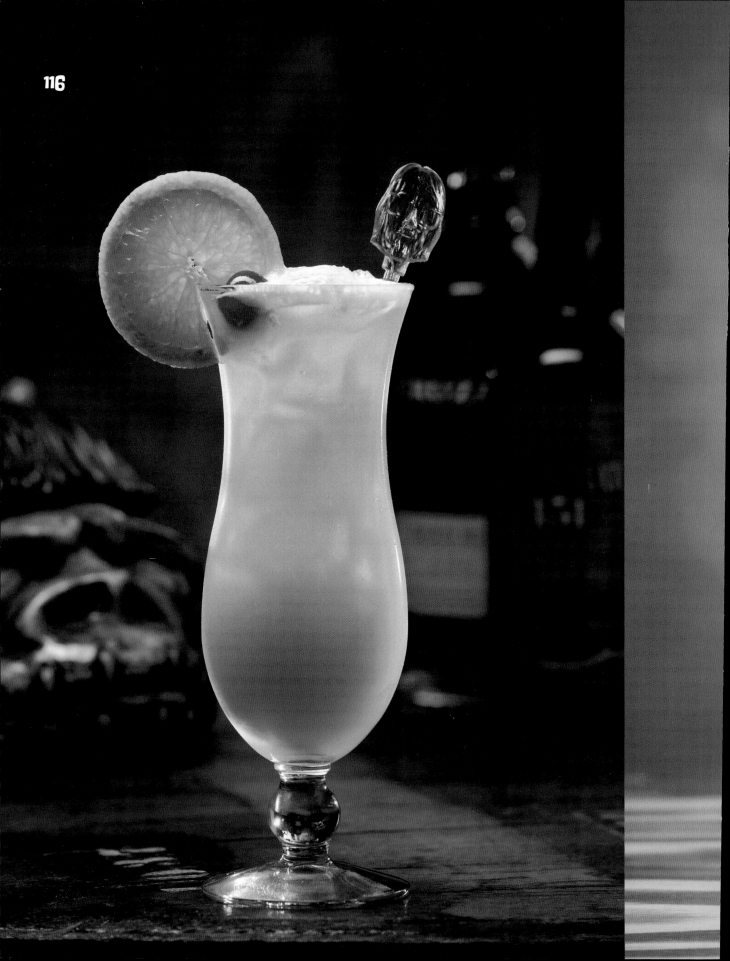

SIX-FOOT KICK

Don't let the innocent look deceive you, this wicked wallop will kick your ass.

1 ounce Cruzan Aged Dark Rum

1 ounce Lemon Hart 151-proof rum

½ ounce falernum

½ ounce ginger syrup

½ ounce lime juice

1 ounce orange juice

2 ounces papaya nectar

Orange wheel and a cherry for garnish

Build over ice in a 14-ounce squall glass, then pour contents into a cocktail shaker.

Shake well, then re-pour into the glass.

Serve garnished with orange wheel and cherry.

SOLANA SHOWDOWN

💀💀💀

This pleasing sipper is a reflection of the tranquil California beach it's named after.

1 ounce Appleton White rum

½ ounce Theia Jasmine Liqueur

½ ounce orange Curacao

½ ounce lemon juice

¼ ounces grenadine

2 ounces orange juice

Orange twist for garnish

 Build over ice in an 8-ounce flute, then pour contents into a cocktail shaker.
 Shake well, then re-pour into the glass.
 Serve garnished with a long twist of orange.

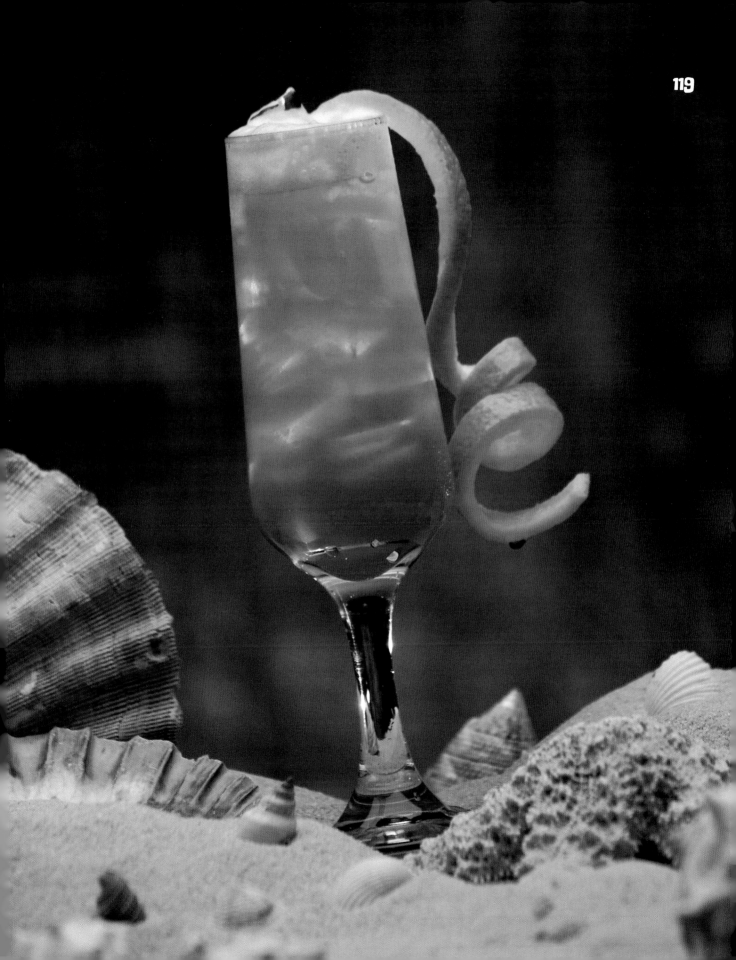

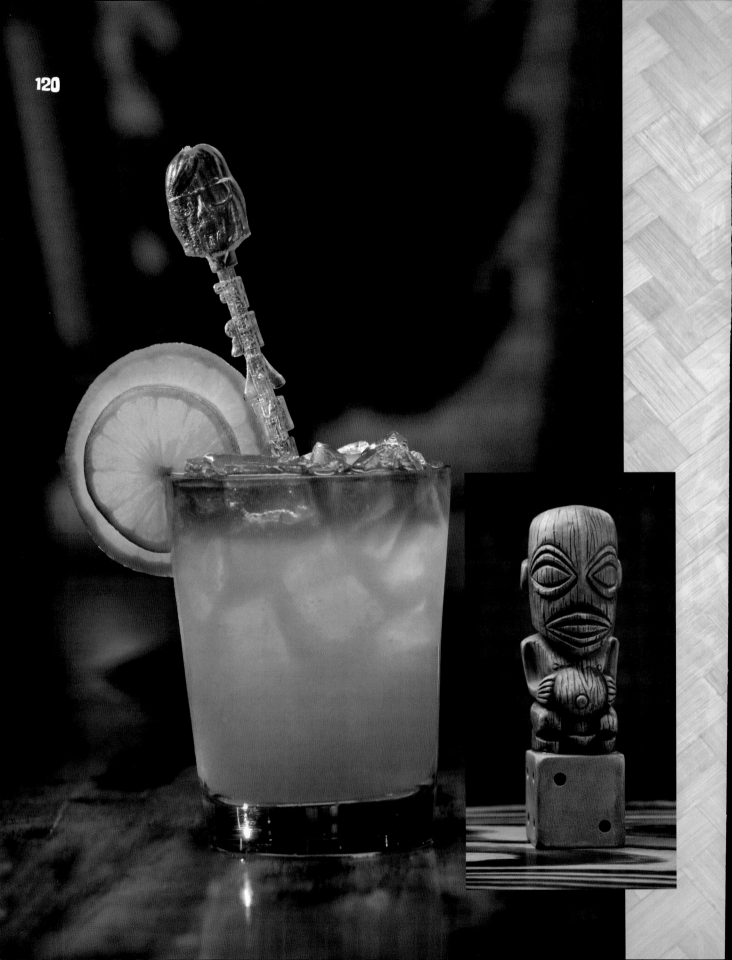

SQUID ZINK

💀 💀 💀

This drink was created for Frankie's second anniversary and the Squid-designed limited-edition tiki mug commemorating the occasion.

Mellow and smooth like its artist namesake, this zesty cooler will stimulate your creative urges. And maybe some primal urges.

1 ounce Sailor Jerry rum

½ ounce orange Curacao

½ ounce falernum

Dash Angostura bitters

½ ounce lime juice

2 ounces mango nectar

1 ounce orange juice

½ ounce Whaler's Original Dark Rum

Lime and orange wheels for garnish

Build all ingredients except the Whaler's over ice in a 14-ounce double-old-fashioned glass (or the commemorative tiki mug if you are lucky enough to own one). Then pour contents into a cocktail shaker.

Without shaking, re-pour contents into the glass.

Float the Whaler's on top, then serve garnished with lime and orange wheels.

STRANDED IN HANA

💀 💀 💀

With its enchanting medley of flavors, this numbing chiller channels the inner peace of rural Maui.

1 ounce Koloa dark rum

½ ounce Lemon Hart 151-proof rum

¼ ounce St. Elizabeth Allspice Dram

½ ounce lime juice

1 ounce papaya nectar

3 ounces Lilikoi juice drink

Build over ice in a 14-ounce double-old-fashioned glass, then pour contents into a cocktail shaker.
Shake well, then re-pour into the glass.
Serve without garnish.

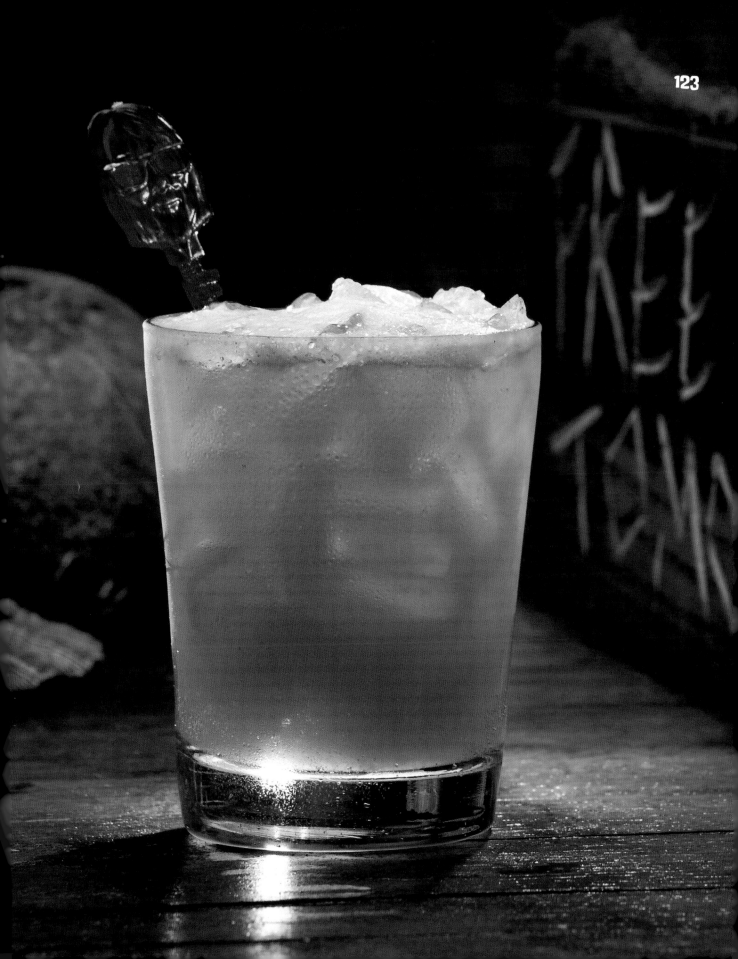

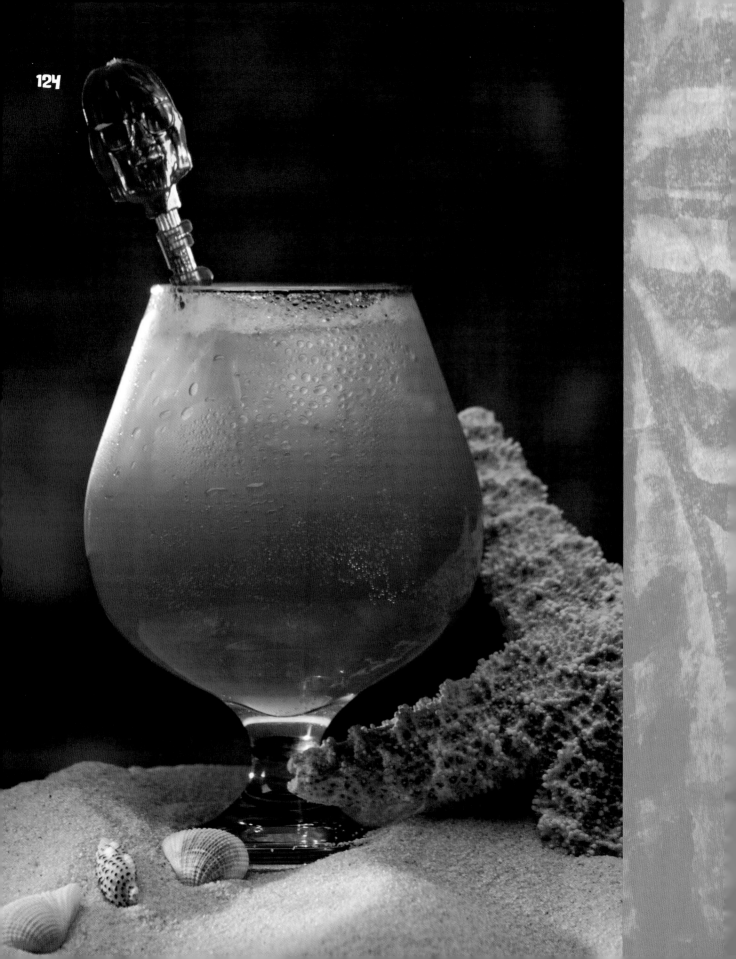

SURFADELIC SMASHUP

💀 💀 💀 💀 💀

With a super-charged burst of high-octane rum, this goosed-up bracer will erase all of your inhibitions.

1 ounce Flor De Cana 4-year-old gold rum

1 ounce Lemon Hart 151-proof rum

½ ounce St. Elizabeth Allspice Dram

¼ ounce simple syrup

½ ounce lime juice

3 ounces strawberry nectar

3 ounces ginger ale

Build over ice in a 17-ounce snifter, then pour contents into a cocktail shaker.

Without shaking, re-pour into the snifter. Serve without garnish.

TANGERINE SPEEDO

Downing one of these zesty refreshers will give you the courage to wear the Speedo. Drinking two will make you want to go commando.

1 ounce Depaz Amber Rhum

¼ ounce Campari

¼ ounce creme de cassis

½ ounce Chambord

½ ounce lime juice

1 ounce pear nectar

1 ounce orange juice

2 ounces club soda

Build over ice in a 14-ounce double-old-fashioned glass, then pour contents into a cocktail shaker.

Shake well, then re-pour into the glass.

Serve without garnish.

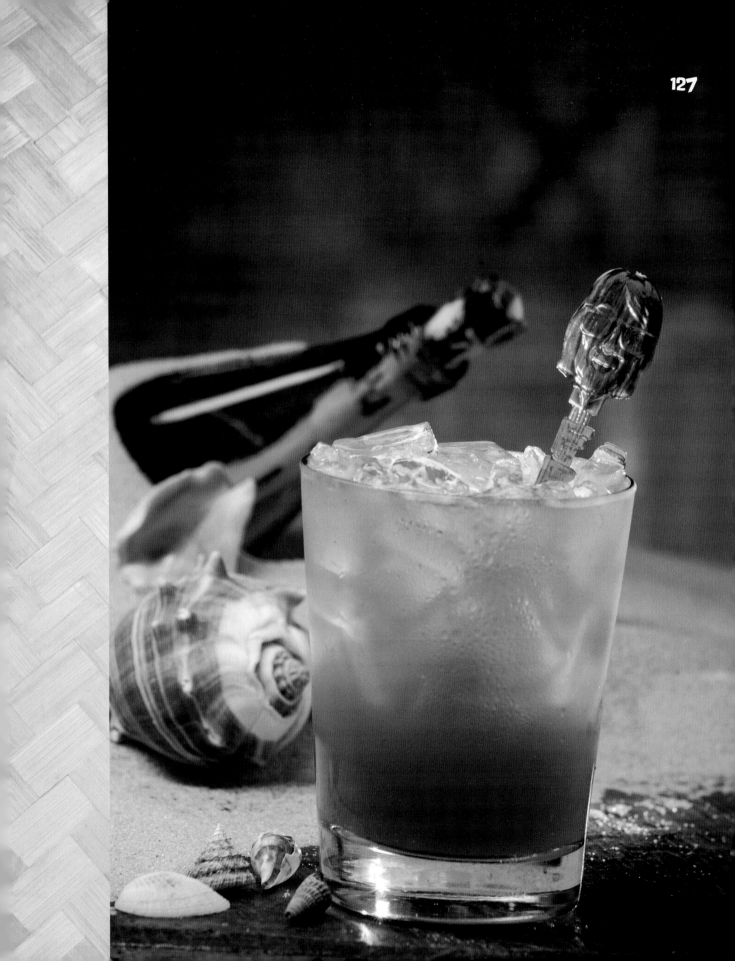

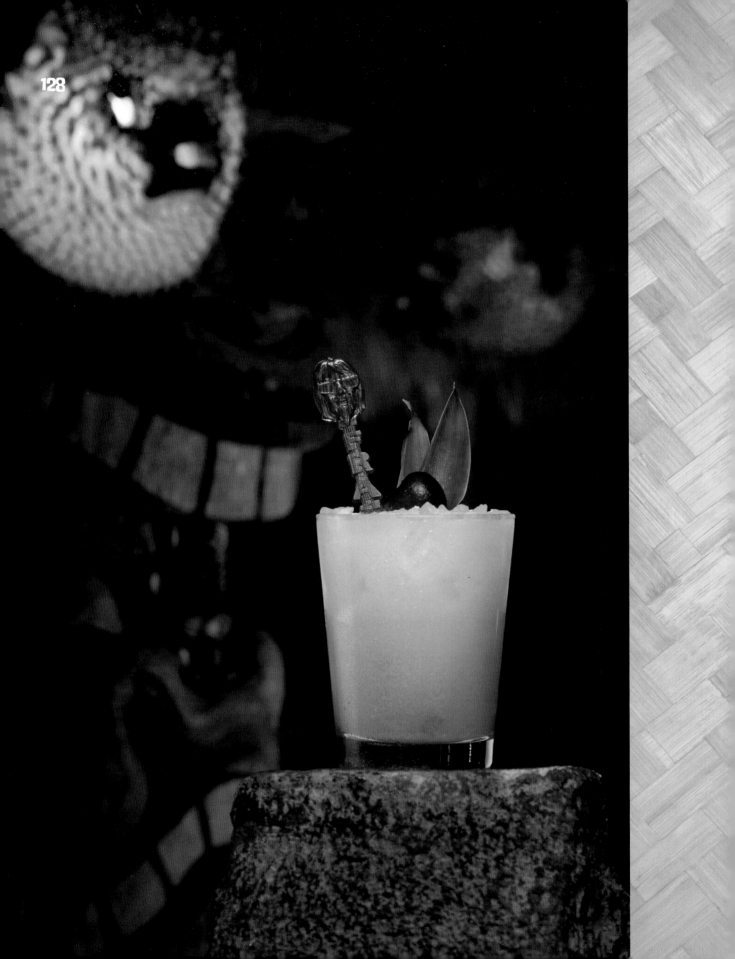

THREE RUM SCUM

💀 💀 💀 💀

Be prepared to apologize to everyone. Too bad you won't remember what for.

½ ounce Hana Bay 151-proof rum

½ ounce Sailor Jerry spiced rum

½ ounce Cruzan Coconut Rum

½ ounce Coco Lopez

½ ounce falernum

2 ounces orange juice

2 ounces pineapple juice

Cherry for garnish

Build over ice in a 14-ounce double-old-fashioned glass, then pour contents into a cocktail shaker. Shake vigorously, then re-pour into the glass.

Serve garnished with a cherry.

THURSTON HOWL

After a couple of these, Lovey Howell will look like Ginger Grant.

1 ounce Appleton Special Gold rum

½ ounce Christian Brothers VS brandy

½ ounce Tanqueray Rangpur gin

¼ ounce white grapefruit juice

¼ ounce cinnamon syrup

½ ounce ginger syrup

3 ounces papaya nectar

3 ounces pineapple juice

Pineapple and cherries for garnish

Build over ice in a 17-ounce snifter, then pour contents into a cocktail shaker. Without shaking, re-pour into the snifter.

Serve garnished with pineapple and cherries.

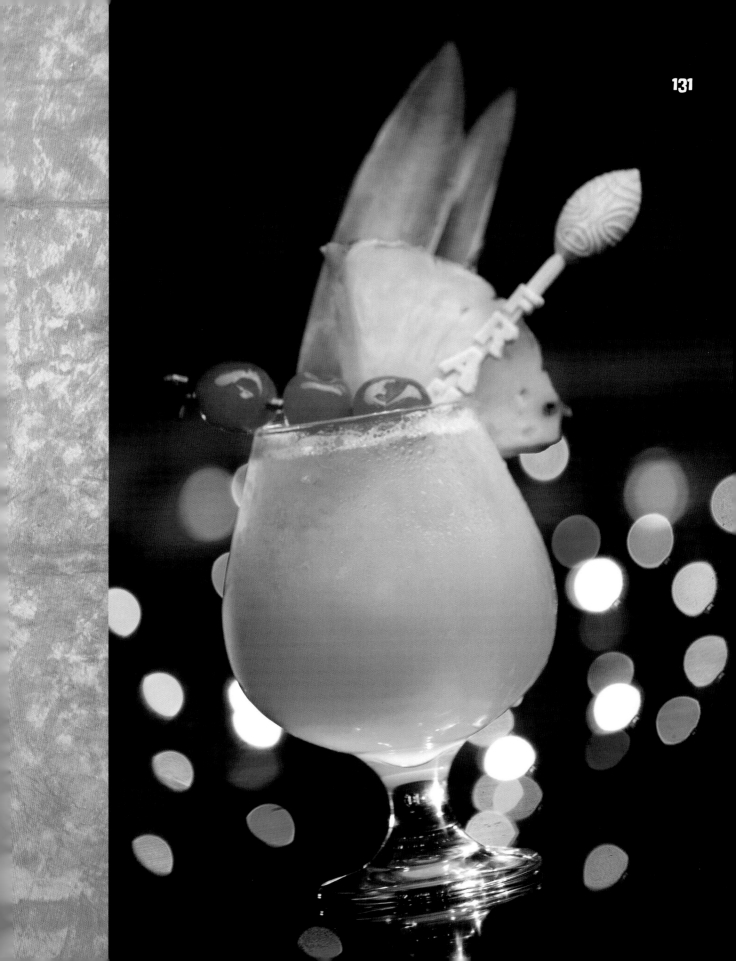

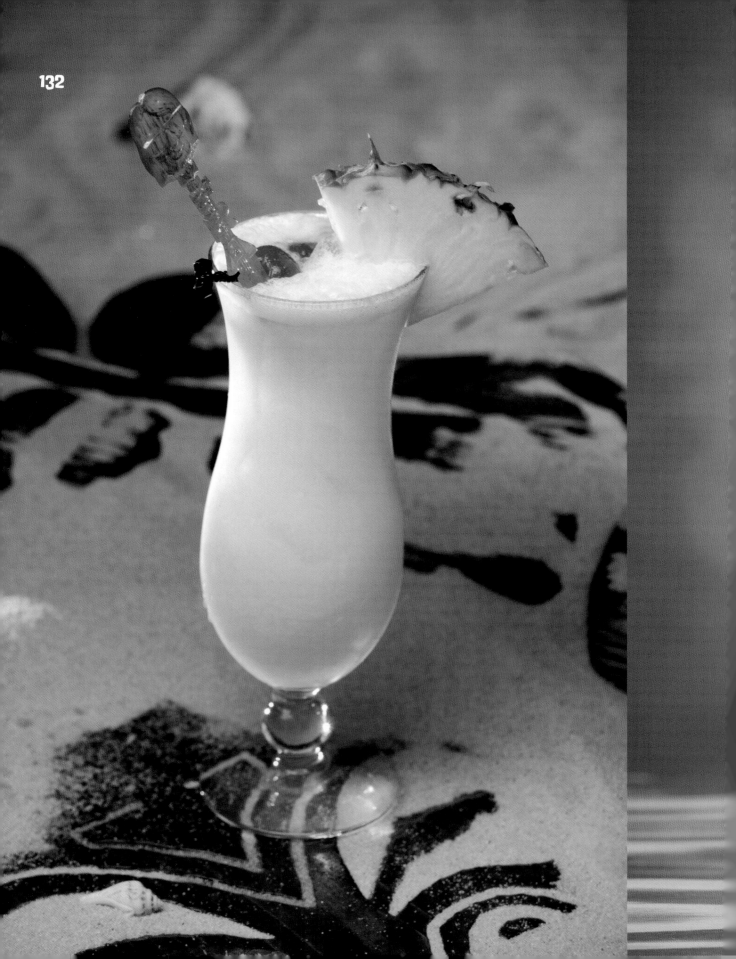

TIDE RIPPER

Beware of false courage offered by this boozy delight. Keep anchored to a barstool, with your seatbelt on.

1 ounce Ketel One Citroen vodka

½ ounce Midori melon liqueur

½ ounce Cruzan Coconut Rum

½ ounce creme de banana

½ ounce milk

2 ounces pineapple juice

Cherries and pineapple for garnish

Build over ice in a 14-ounce squall glass, then pour contents into a cocktail shaker.

Shake well until frothy, then re-pour into the glass.

Serve garnished with cherries and pineapple.

TIKI BANDIT

☠ ☠ ☠

A jackpot of island delights, this dreamy nectar will keep you rolling sevens.

¾ ounce Appleton Special Gold rum

¾ ounce Cruzan Pineapple Rum

½ ounce blue Curacao

½ ounce orgeat syrup

½ ounce passion fruit syrup

2 ounces pineapple juice

½ ounce white grapefruit juice

2 ounces ginger ale

Pineapple and cherries for garnish

Build over ice in a 17-ounce snifter, then pour into a cocktail shaker.
Without shaking, re-pour into snifter.
Serve garnished with pineapple and cherries.

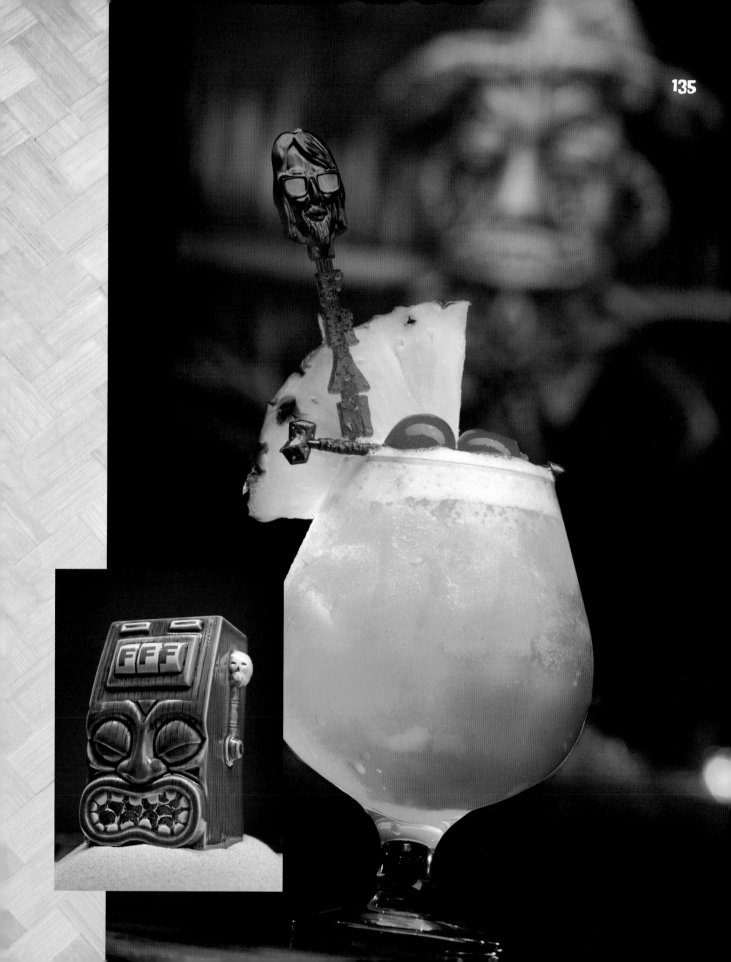

TONGA REEFER

One hit from this high-octane taste treat will mellow out even the most stone-faced islander.

1 ounce Cruzan guava rum

½ ounce Whaler's Vanille rum

½ ounce Wray & Nephew White Overproof Rum

½ ounce lime juice

2 ounces guava nectar

½ ounce Whaler's Original Dark Rum

Vanilla bean and edible flower for garnish

 Fill a 10-ounce pilsner glass with ice, then add all ingredients except the Whaler's dark rum. Pour contents into a cocktail shaker. Shake well, then re-pour into the glass. Float the dark rum on top.

 Serve garnished with vanilla bean and, if you are feeling the appropriate high, a floral accent.

WAI'ANAE WIPEOUT

Catch the wave of this gassed-up chiller and you will be drinking with the pros.

1 ounce Wray & Nephew White
 Overproof Rum

1 ounce Cruzan Mango Rum

½ ounce blue Curacao

½ ounce ginger syrup

2 ounces mango nectar

½ ounce lime juice

Cherries and an orange wheel for
 garnish

Build over ice in a 14-ounce squall glass, then pour contents into a cocktail shaker.
 Shake vigorously, then re-pour into the glass.
 Serve garnished with cherries and an orange wheel.

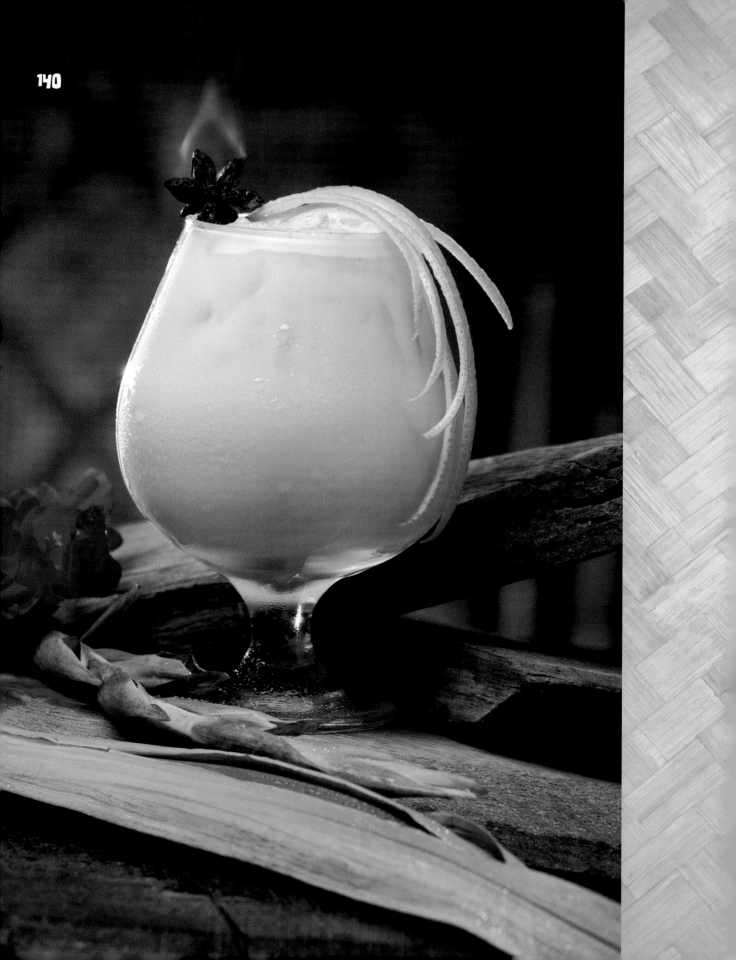

WHITE DRAGON

💀 💀 💀

An exotic delight that will ignite the fire in your soul.

2 ounces Flor De Cana white rum

½ ounce Tuaca vanilla citrus liqueur

½ ounce Midori melon liqueur

½ ounce St. Elizabeth Allspice Dram

1 ounce cold green tea

1 ounce simple syrup

½ ounce sweetened condensed milk

½ ounce coconut milk

Star anise and orange-zest ribbons for garnish

Build over ice in a 17-ounce snifter, then pour contents into a cocktail shaker.

Shake well, then re-pour into the snifter.

Serve garnished with lighted star anise and ribbons of orange zest.

WILD WATUSI

💀 💀 💀 💀 💀

Topped with a 160-proof float, this revved-up hullabaloo will make you shoo-bop 'til you drop.

½ ounce Cruzan Mango Rum

½ ounce Cruzan Aged Light Rum

½ ounce Tuaca vanilla citrus liqueur

½ ounce peach schnapps

½ ounce lime juice

2 ounces orange juice

Dash Angostura bitters

½ ounce Chambord

½ ounce Stroh 160-proof rum

Fill a 14-ounce double-old-fashioned glass with ice, then add rums, Tuaca, schnapps, juices and bitters. Pour contents into a cocktail shaker. Without shaking, re-pour into the glass. Drizzle Chambord down the inside of the glass. Float Stroh rum on top. Serve without garnish.

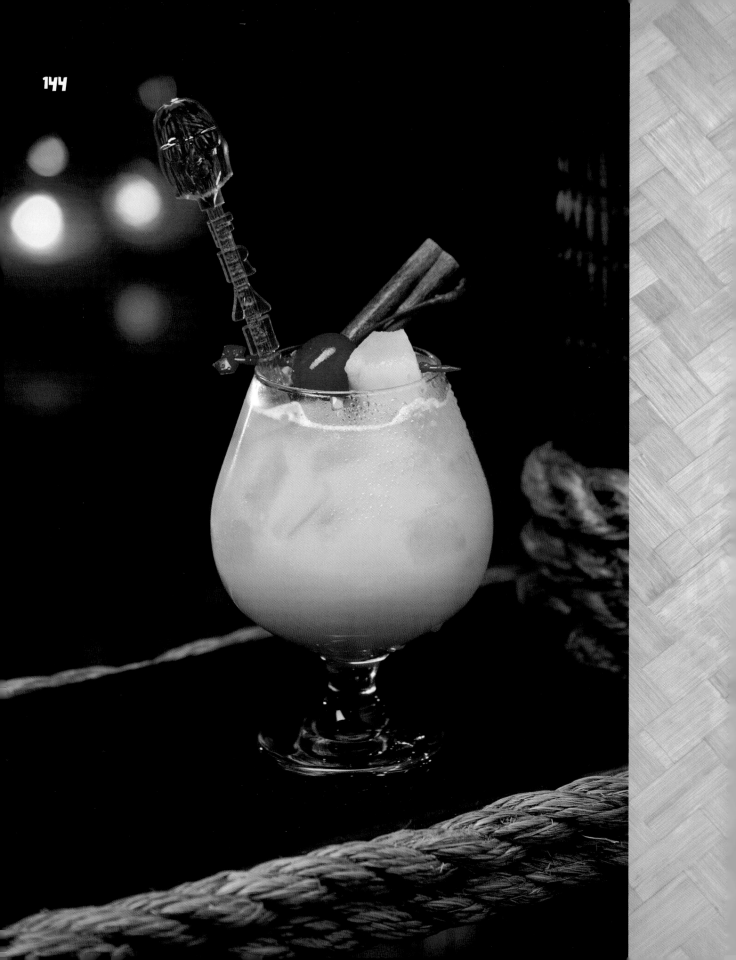

WITCHING WAHINE

This enchanting mosaic of flavor will transform every woman into an island enchantress. And every man into a horny devil.

2 ounces Corona beer

2 ounces silver tequila

½ ounce Grand Marnier

½ ounce hibiscus liqueur

½ ounce cinnamon syrup

¼ ounce hibiscus syrup

¼ ounce vanilla syrup

2 ounces orange juice

Pineapple, cherry and a cinnamon stick for garnish

Fill a 17-ounce snifter with ice, then add the Corona. Add the rest of the ingredients to a cocktail shaker with just a few ice cubes. Shake well, then pour the contents over the beer in the snifter. Serve garnished with pineapple, cherry and a cinnamon stick.

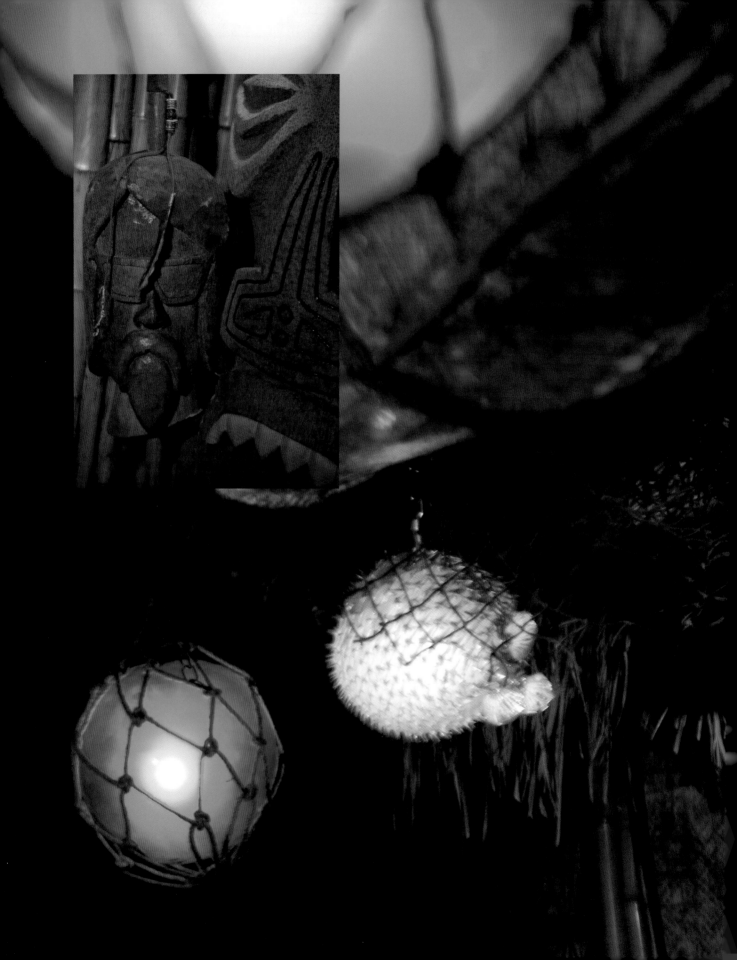

CLASSIC TIKI DRINKS

Many of the traditional tiki drinks featured in this book have been around since as early as the 1930s, and all of them have remained popular through generations of changing tastes. They're time-honored classics with well-documented recipes.

However, a Mai Tai you order in Florida may be subtly different from one you had in California and a Zombie in Chicago might taste nothing like the one you enjoyed in Honolulu, as different bartenders have different ways of doing things. And when it comes to classic tiki drinks, even respected historians sometimes argue the origins.

So who's right and who's wrong? Nobody can honestly say for sure, because in a barroom laboratory it stands to reason that a drink might be somewhat altered between the time it is first invented and the time the recipe eventually is written down—the conclusion being that nobody really knows.

So, as with any great tiki bar, Frankie's has put its own spin on the classics, while staying as true as possible to tradition.

BLOOD AND SAND

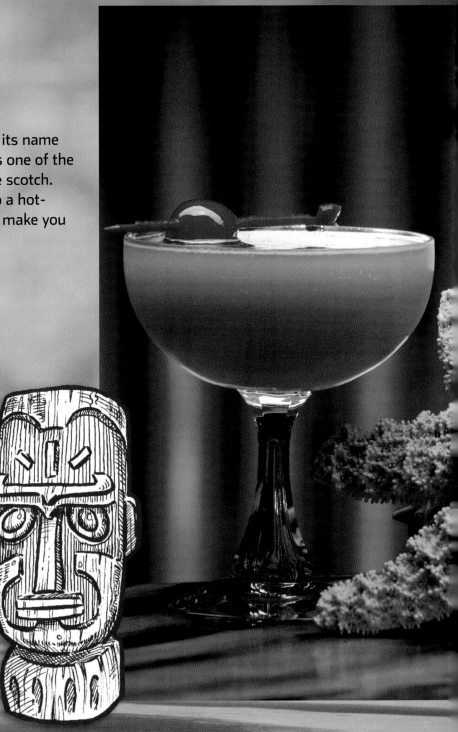

This sophisticated bracer gets its name from a Valentino movie, and is one of the few classic cocktails to feature scotch. Will drinking one turn you into a hot-blooded lover? It will certainly make you think you are.

1 ounce scotch

¾ ounce cherry brandy

¾ ounce sweet vermouth

¾ ounce orange juice

Cherry for garnish

Pour all ingredients into a cocktail shaker over ice. Shake then strain into a chilled 5-ounce coupe glass.

Serve garnished with a cherry.

COBRA'S FANG

This attacking pick-me-up, created in the 1930s, will make you want to bite it back.

½ ounce Myers's dark rum

½ ounce Lemon Hart 80-proof rum

2 ounces Hawaiian Sun Luau Punch

½ ounce orange juice

½ ounce falernum

¼ ounce lime juice

Dash Angostura bitters

Dash grenadine

Cherries and an orange twist for garnish

Build over ice in an 8-ounce flute, then pour contents into a cocktail shaker. Without shaking, re-pour contents into the glass.

Serve garnished with two cherries and an orange twist.

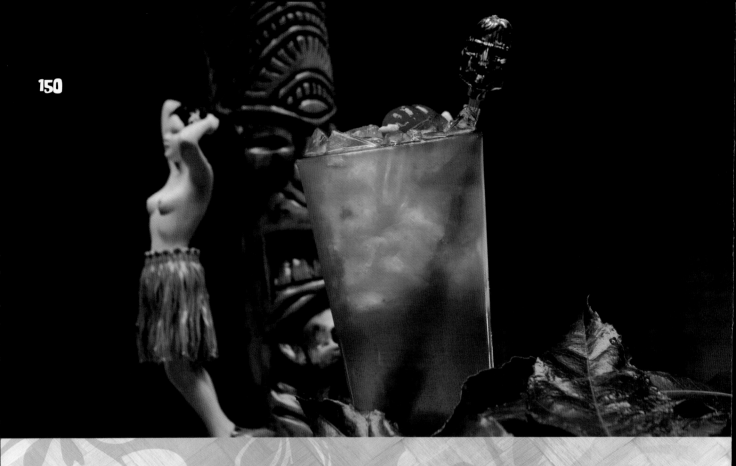

DOCTOR FUNK

💀 💀 💀 💀

Influenced by a drink concocted in Samoa by an actual Dr. Funk as a prescription for heat stroke, this zesty bracer will beat back a lot more than the weather.

2½ ounces Myers's dark rum

¼ ounce Pernod

2½ ounces lime juice

½ ounce lemon juice

½ ounce grenadine

1½ ounces club soda

Cherries for garnish

Pour all ingredients except the club soda over ice in a 14-ounce double-old-fashioned glass, then pour into a cocktail shaker.

Without shaking, re-pour contents into the glass, then top with the club soda.

Serve garnished with cherries.

Dr. Funk, MD
Take 2 +
Call me in the
morning.

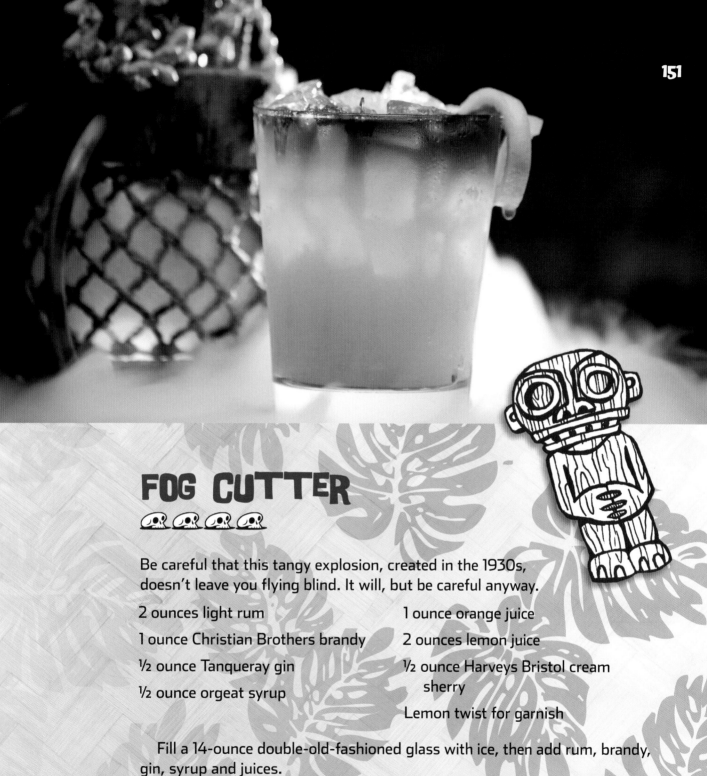

FOG CUTTER

💀 💀 💀 💀

Be careful that this tangy explosion, created in the 1930s, doesn't leave you flying blind. It will, but be careful anyway.

2 ounces light rum

1 ounce Christian Brothers brandy

½ ounce Tanqueray gin

½ ounce orgeat syrup

1 ounce orange juice

2 ounces lemon juice

½ ounce Harveys Bristol cream sherry

Lemon twist for garnish

Fill a 14-ounce double-old-fashioned glass with ice, then add rum, brandy, gin, syrup and juices.

Pour contents into a cocktail shaker. Shake well, then re-pour into the glass. Float the sherry on top.

Serve garnished with a lemon twist.

LA FLORIDA DAIQUIRI

Introduced to the world by bartender Constantino Ribalaigna at the La Florida bar (AKA El Floridita) in Havana, it has over the years become the quintessential rum drink.

2 ounces Havana Club Anejo 3 Anos rum

1 teaspoon superfine sugar

1 teaspoon maraschino liqueur

1 ounce hand-squeezed (no mechanical devices) lime juice

Lime wheel for garnish

Shake and strain into a chilled 8-ounce martini glass.
Serve garnished with a lime wheel.

LAPU LAPU

☠ ☠ ☠

A variation of the Chief Lapu Lapu, named for the Filipino island ruler who killed Magellan in 1521, this fruity refresher gained its popularity as the signature drink of the recently shuttered Royal Hawaiian in Laguna Beach.

1½ ounces light rum

½ ounce passion fruit syrup

½ ounce orgeat syrup

3 ounces pineapple juice

2 ounces orange juice

½ ounce Whaler's Original Dark Rum

Fill a 17-ounce snifter to the top with ice, then add light rum, syrups and juices.

Pour contents into a cocktail shaker. Without shaking, re-pour contents into the snifter.

Float the dark rum on top.

Serve with no garnish.

MAI TAI

The name of this dark-rum knockout—the gold standard of tiki drinks—translates from Tahitian as "out of this world." In the 1930s both Trader Vic Bergeron and Donn Beach claimed to have invented the drink, but years later Bergeron confessed that it originated with Beach.

Half a large lime, freshly cut

1 ounce Myers's dark rum

1 ounce Lemon Hart 80-proof rum

½ ounce simple syrup

1 ounce orgeat syrup

1 ounce orange Curacao

Sprig of mint and a cherry for garnish

Squeeze the juice from the lime half into a 14-ounce double-old-fashioned glass, then drop in the rind. Add rums, syrups and orange Curacao, then fill the glass to the top with ice.

Pour contents into a cocktail shaker. Shake, then re-pour into the glass. The lime rind should float to the top.

Serve garnished with a sprig of mint and a cherry.

MISSIONARY'S DOWNFALL

Many do-gooders have found themselves in need of salvation after trying to convert this minty delight.

2 one-inch cubes fresh pineapple

6 mint leaves

1 ounce Bacardi Superior light rum

½ ounce peach schnapps

½ ounce Christian Brothers brandy

1½ ounces lime juice

Sprig of mint for garnish

 In a mixing glass, muddle the pineapple cubes and the mint leaves. Transfer to an 11-ounce chimney glass, then add the rum, schnapps, brandy and lime juice and fill to the top with ice.

 Pour contents into a cocktail shaker. Shake well, then re-pour into the chimney glass. Serve garnished with a sprig of mint.

MOJITO

Originally concocted for medicinal purposes, a crude form of the modern mojito can be traced to the 16th century. A few hundred years later, a civilized version of the popular drink was created in Havana.

2 ounces Havana Club Anejo 3 Anos rum

2 sprigs of mint

1 teaspoon turbinado sugar

4 lime wedges

Splash of club soda

In a mixing glass, muddle all ingredients except the club soda until the sugar is dissolved. Then pour contents (stems and all—they don't pluck the leaves in Cuba) into an 11-ounce chimney glass.

Fill the glass with ice and top with club soda. Serve without garnish.

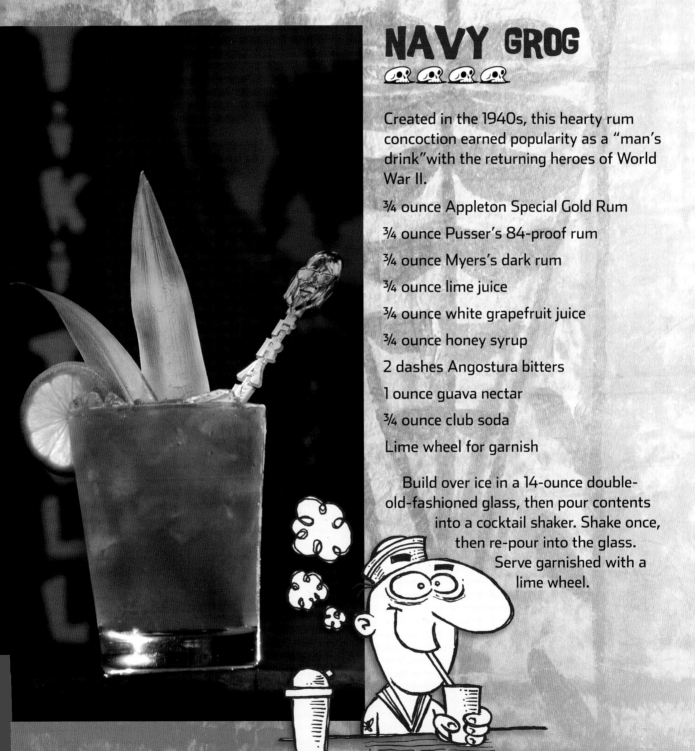

NAVY GROG

Created in the 1940s, this hearty rum concoction earned popularity as a "man's drink" with the returning heroes of World War II.

¾ ounce Appleton Special Gold Rum

¾ ounce Pusser's 84-proof rum

¾ ounce Myers's dark rum

¾ ounce lime juice

¾ ounce white grapefruit juice

¾ ounce honey syrup

2 dashes Angostura bitters

1 ounce guava nectar

¾ ounce club soda

Lime wheel for garnish

Build over ice in a 14-ounce double-old-fashioned glass, then pour contents into a cocktail shaker. Shake once, then re-pour into the glass. Serve garnished with a lime wheel.

PIKAKE

💀 💀 💀 💀

This is Frankie's update of this dazzling medley of flavors that was a staple during the tiki heyday along the California coast.

1½ ounces Bacardi Superior light rum

1 ounce Van Der Hum liqueur

½ ounce lime juice

½ ounce vanilla syrup

Lime wheel for garnish

Build over ice in a cocktail shaker. Shake well, then strain into a chilled 8-ounce martini glass.

Serve garnished with a lime wheel.

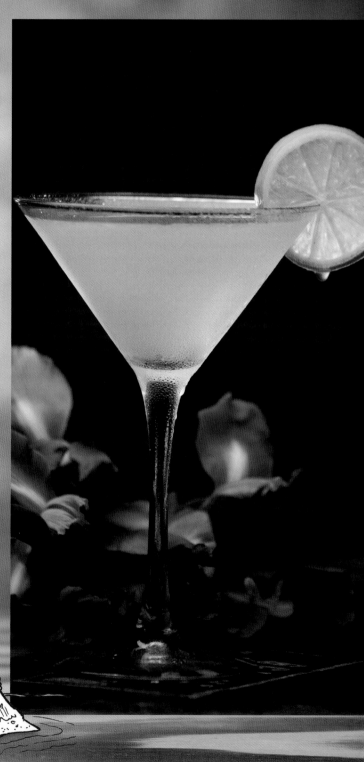

SCORPION

This drink generally is served in a bowl with multiple straws, but at Frankie's we make them individually. It's brisk, invigorating and smooth going down, without the sting the name suggests.

1½ ounces Bacardi Superior light rum

1 ounce Christian Brothers VS brandy

½ ounce orgeat syrup

½ ounce passion fruit syrup

1½ ounces lemon juice

2 ounces orange juice

Fresh gardenia for garnish

Build over ice in a 14-ounce double-old-fashioned glass, then pour contents in a cocktail shaker.

Shake well, then re-pour into the glass.

Serve garnished with a fresh gardenia.

SHARK'S TOOTH

More of a sweet tooth than a shark bite. But be careful, because after a couple of these flavorful elixirs, fins will be circling.

1 ounce Appleton 12 rum

1 ounce Mount Gay Eclipse rum

1 ounce pineapple juice

½ ounce lime juice

¼ ounce simple syrup

¼ ounce cherry juice

Pineapple and a cherry for garnish

Build over ice in an 8-ounce footed highball glass, then pour contents into a cocktail shaker.

Shake well, then re-pour into the glass.

Serve garnished with pineapple and a cherry.

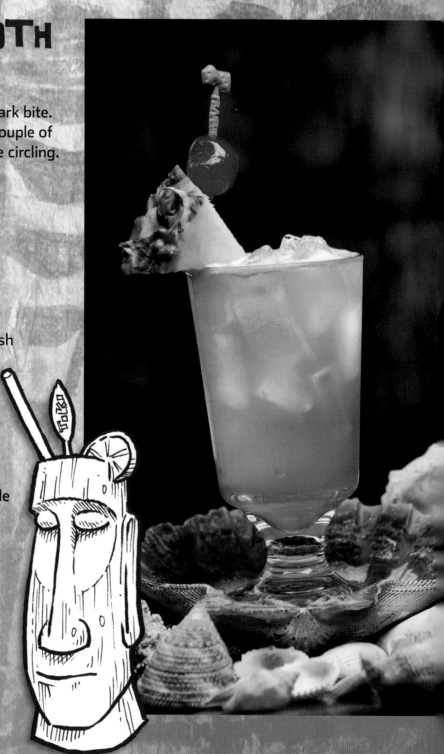

THREE DOTS AND A DASH

Morse code for "victory," this edgy mix of flavors is guaranteed to send the right message.

1½ ounces St. James Royal Ambre Rum

½ ounce Lemon Hart 80-proof rum

¼ ounce St. Elizabeth Allspice Dram

½ ounce falernum

Dash Angostura bitters

½ ounce honey syrup

½ ounce lime juice

½ ounce orange juice

Pineapple and three cherries for garnish

Build over ice in a 14-ounce double-old-fashioned glass, then pour contents into a cocktail shaker. Without shaking, re-pour into the glass. Serve garnished with pineapple and three cherries.

VICIOUS VIRGIN

This drink has often been blended and served in a Champagne coupe. Frankie's version is tall and on the rocks. Insert virginity jokes at your own risk.

1 ounce Cruzan Aged Light Rum

½ ounce Myers's dark rum

½ ounce Cointreau

¼ ounce falernum

¾ ounce lime juice

Lime wheel and cherry for garnish

Build over ice in an 11-ounce chimney glass, then pour contents into a cocktail shaker. Without shaking, re-pour into the glass.

Serve garnished with lime wheel and a cherry.

YELLOWBIRD

💀 💀 💀

A Caribbean classic of debatable origin, this savory delight was hijacked to California and tiki-fied in the 1950s.

1 ounce Cruzan Aged Light Rum

½ ounce Galliano

½ ounce creme de banana

½ ounce orange juice

½ ounce pineapple juice

Build over ice in a cocktail shaker. Shake once, then strain into a 5-ounce coupe glass.

Serve without garnish.

ZOMBIE

Created in the 1930s as a hangover cure, this combustible combination of rums and juices will ... well, the name says it all.

¾ ounce Appleton Special Gold rum

¾ ounce Myers's dark rum

½ ounce Lemon Hart 151-proof rum

½ ounce maraschino liqueur

1 drop Pernod

¼ ounce falernum

¼ ounce grenadine

2 dashes Angostura bitters

2 ounces pineapple juice

½ ounce white grapefruit juice

¾ ounce lime juice

Pineapple and cherries for garnish

Build over ice in a 14-ounce double-old-fashioned glass, then pour contents into a cocktail shaker. Shake, then re-pour into the glass.
Serve garnished with pineapple and cherries.

THE BOOZE

Brand names are used in many of these recipes because subtleties in flavor are important to the overall taste of the drink. We understand that certain products may not always be available to you and, unfortunately, for many of the drinks there are no suitable substitutions. However, some of the recipes do allow for certain substitutions that will keep the drink true to its intended flavor.

Amaretto liqueur—Preferred brands are Leroux and Disaronno.

Apricot brandy—Preferred brands are Leroux and DeKuyper.

Blackberry brandy—Preferred brands are Leroux and DeKuyper.

Blue Curacao—We use only Leroux. Other brands turn greenish when mixed with fruit juice.

Champagne—Any authentic Champagne will do.

Cherry brandy—Preferred brands are Leroux and DeKuyper.

Crème de banana—Preferred brands are Leroux and DeKuyper.

Crème de cassis—Preferred brands are Leroux and DeKuyper.

Gold rum—Preferred brands are Cruzan and Bacardi.

Havana Club Anejo 3 Anos rum—Use only the original Cuban-distilled Havana Club, as a similarly named rum distilled in Puerto Rico is a cheap knockoff.

Hibiscus liqueur—Preferred brand is Fruitlab.

Light rum—Preferred brands are Cruzan and Bacardi.

Madeira wine—Use any brand of the sweet Malmsey variety.

Maraschino liqueur—Preferred brand is Luxardo.

Orange Curacao—Preferred brands are Leroux and DeKuyper.

Peach schnapps—Preferred brands are Leroux and DeKuyper.

Scotch—Any premium brand will do.

Sweet vermouth—Preferred brand is Martini & Rossi.

Tequila—Any premium silver tequila will do.

Triple sec—Preferred brands are Leroux and DeKuyper.

Vodka—Any premium brand will do.

Whaler's Original Dark Rum—If this rum is not available in your area, Diamond Head dark rum is an acceptable substitute.

MIXERS AND SYRUPS

As with liquor, subtleties in the flavors of certain brands of mixers can affect the overall taste of the drink. For some products there are no acceptable substitutions, while with others there is some flexibility while still keeping the drink true to its intended flavor.

7Up—Sprite also can be used.

Apricot nectar—Preferred brand is Kern's.

Aztec chocolate bitters—Preferred brand is Fee Brothers.

Cherry bitters—Preferred brand is Fee Brothers.

Cherry juice—The juice from the bottom of a jar of maraschino cocktail cherries.

Cinnamon syrup—Best if made from scratch (see recipe in following section). In a pinch, Torani or DaVinci can be substituted.

Club soda—Preferred brands are Canada Dry and Schweppes. Perrier also can be used

Coconut milk—Fresh is preferable, but A Taste Of Thai and Thai Kitchen are acceptable substitutes.

Condensed milk—Preferred brands are Carnation and Nestle.

Cranberry juice cocktail—Not to be confused with 100-percent cranberry juice. Preferred brand is Ocean Spray.

Date syrup—Make from scratch (see recipe in following section), as there is no acceptable substitute.

Dulce de leche—Best if made from scratch (see recipe in following section). In a pinch, Nestle La Lechera can be substituted.

Falernum—Make from scratch (see recipe in following section), as there is no acceptable substitute.

Five-spice syrup—Make from scratch (see recipe in following section), as there is no acceptable substitute.

Ginger ale—Preferred brands are Canada Dry and Schweppes.

Ginger beer—Best if made from scratch (see recipe in following section). Cock 'N Bull is the only acceptable substitute.

Ginger syrup—Best if made from scratch (see recipe in following section). In a pinch, Torani can be substituted.

Green tea—Brew with any quality brand of tea bags.

Grenadine—Preferred brand is Rose's. Finest Call can be substituted.

Guava nectar—Preferred brand is Hawaiian Sun. Kern's can be substituted.

Hibiscus syrup—Best if made from scratch (see recipe in following section). In a pinch, Torani can be substituted.

Honey syrup—Make from scratch (see recipe in following section), as there is no acceptable substitute.

Ichimi togarashi—Any brand of this seven-spice Japanese chili powder will do.

Lemon juice—Always squeeze it fresh.

Lilikoi—A passion fruit juice drink made by Hawaiian Sun.

Lime juice—Always squeeze it fresh.

Luau Punch—Preferred brand is Hawaiian Sun.

Macadamia nut liqueur—Preferred brand is Trader Vic's.

Mango nectar—Preferred brand is Kern's.

Milk—Always use pasteurized whole milk, unless recipe calls for non-fat milk.

Orange bitters—Preferred brand is Fee Brothers.

Orange flower water—Preferred brands are Noriat and Fee Brothers.

Orange juice—If you can't squeeze your own, we recommend Tropicana with no pulp.

Orgeat syrup—To make it from scratch is not cost-effective and very time-consuming, therefore we recommend Monin.

Papaya nectar—Preferred brands are L&A and Kern's.

Passion fruit syrup—Preferred brand is Monin.

Pear nectar—Preferred brand is Kern's.

Pickled ginger liquid—The liquid in the bottom of a jar of pickled ginger.

Pineapple juice—Preferred brand is Dole.

POG—A tropical juice drink containing passion fruit, orange and guava. Preferred brand is Hawaiian Sun.

Red passion fruit syrup—Preferred brand is Monin.

Rose water—Preferred brand is Fee Brothers.

Simple syrup—Make from scratch (see recipe in following section), as there is no acceptable substitute.

Soursop juice—Available in most Asian and Hispanic markets, any brand is acceptable.

Soy sauce—Any authentic brand will do.

Sriracha hot sauce—Any authentic brand will do.

Strawberry nectar—Preferred brand is Kern's.

Sweet and sour—Make from scratch (see recipe in following section), as there is no acceptable substitute.

Tomato juice—Preferred brand is Campbell's.

White grapefruit juice—If you can't squeeze your own, our preferred brand is Ocean Spray, though Tropicana also is good.

SYRUP RECIPES

CINNAMON SYRUP

2½ cups granulated sugar

2½ cups bottled or purified water

3 cinnamon sticks, broken into shards

Simmer ingredients in a saucepan over medium heat, stirring frequently, until sugar is completely dissolved. Bring to a boil for 2 minutes. Remove from heat and allow to steep for at least one hour.

Strain liquid through a fine-mesh strainer, then funnel into a bottle and refrigerate.

Makes 1 liter.

DATE SYRUP

1 cup granulated syrup

1 cup bottled or purified water

4 large Medjool dates (halved and pitted)

Simmer together in a saucepan over medium heat, stirring frequently, until sugar is completely dissolved. Bring to a boil, then reduce heat and simmer for 10 minutes, skimming white foam from the top.

Remove from heat, allowing the mixture to steep for one hour. Strain liquid through a fine-mesh strainer, then funnel into a bottle and refrigerate.

Makes 1 cup.

DULCE DE LECHE

1 quart whole milk

1 cup non-fat milk

1 ⅔ cup turbinado sugar

¼ teaspoon vanilla extract

⅛ teaspoon ground cinnamon

Stirring occasionally, simmer ingredients in a saucepan over low heat until the mixture reduces to a thick brown pudding. This process will take 2 to 3 hours.

Remove from heat and let the mixture cool.

Strain through a fine-mesh strainer, funnel into a bottle and refrigerate.

Makes 10 ounces.

FALERNUM

¼ cup whole raw unsalted almonds, shelled

Pea-sized piece of whole nutmeg

12 limes

½ pound fresh ginger

16 ounces Wray & Nephew White Overproof Rum

20 whole cloves

2 whole allspice berries

¼ teaspoon almond extract

¾ cup granulated sugar

¾ cup bottled or purified water

Place the almonds in a dry skillet on top of the stove and toast for 5 minutes, or until they begin to brown. Let cool, then crack them with the bottom of a cold pan or the side of a chef's knife. Using the same method, crack the nutmeg into smaller pieces.

Using a Microplane grater, zest the limes and set the zest aside. Then squeeze the juice. Straining off the pulp, set aside 4½ ounces of lime juice in a tightly covered container and refrigerate until the next day.

Rinse the ginger and cut into matchstick-sized pieces until you have 1/3 cup. (Peeled or not is fine, as long as the ginger is clean.)

In a covered glass container (like a 1 liter-pitcher or carafe with a large opening), combine the rum, lime zest, toasted almonds, cloves, nutmeg, allspice berries and ginger. Cover and allow to macerate at room temperature for 24 hours.

After 24 hours, pour the macerated liquid into a large mixing cup through a fine-mesh strainer. Wearing powder-free exam gloves (otherwise your fingernails will turn green), hand-squeeze as much extra liquid as you can from the solids through the strainer. Discard the solids, then add the almond extract and the reserved lime juice.

Separately, combine the sugar and water. Stir until the sugar is completely dissolved, then add to the macerated liquid. Stir well, then funnel into a bottle. Cover tightly and refrigerate for up to two weeks.

Makes 750 ml.

FIVE-SPICE SYRUP

16 ounces bottled or purified water

3 heaping tablespoons five-spice powder

6 tablespoons turbinado sugar

Combine water and five-spice in a medium saucepan and bring to a boil. Reduce heat and simmer for 15 minutes.

As the five-spice will have gelled, strain mixture through a fine-mesh strainer, reserving the liquid. There should be approximately 8 ounces of liquid left.

Place the liquid back in the pot and add the sugar. Simmer over medium heat until the sugar dissolves.

Remove from heat and let cool. Funnel into a bottle and refrigerate.

Makes 8 ounces.

GINGER BEER

1½ cups turbinado sugar

1½ cups purified or bottled water

½ pound fresh ginger (enough to yield 8 ounces of juice)

10 ounces lime juice

6 ounces lemon juice

80 ounces purified or bottled water

5-gram packet champagne yeast

8 16-ounce brown EZ Cap bottles

In a saucepan over medium heat, simmer turbinado sugar and 1½ cups water until sugar is completely dissolved. Set syrup aside and let cool.

Working with all ingredients at room temperature, peel the ginger root and liquefy in a high-speed juicer until you have 8 ounces of liquid. Through a mesh strainer, funnel the ginger juice, lime juice, lemon juice and 80 ounces of water into a 1-gallon jug. Add the sugar syrup.

Place 26 grains of champagne yeast into each bottle. Fill each bottle with the mixture from the jug, then immediately seal and shake. Make sure to shake the jug between fillings to ensure an even distribution of sediment.

After 48 hours at room temperature, refrigerate until cold. Open carefully.

Makes 8 16-ounce bottles.

GINGER SYRUP

2½ cups granulated sugar

2½ cups bottled or purified water

1 cup sliced ginger (no need to peel it as long as it has been rinsed)

Simmer ingredients in a deep saucepan over medium heat, stirring frequently, until the sugar is completely dissolved.

Bring to a boil and boil for 2 minutes. Watch closely, as ginger syrup has a tendency to boil over. If the mixture begins to foam, carefully lower heat, retaining the boil.

Remove from heat and let steep for at least one hour.

Strain liquid through moistened cheesecloth, squeezing remaining moisture from the ginger into the mix for maximum flavor.

Funnel into a bottle and refrigerate.

Makes 1 liter.

HIBISCUS SYRUP

2½ cups granulated sugar

2½ cups bottled or purified water

2 hibiscus herbal tea bags (or 2½ ounces dried hibiscus flowers)

Simmer sugar and water together in a saucepan over medium heat, stirring frequently, until sugar is completely dissolved.

Remove from heat and add the tea bags. Steep to your desired taste as the mixture cools.

Funnel into a bottle and refrigerate.

Makes 1 liter.

HONEY SYRUP

½ cup honey

½ cup hot water

Mix the honey and water together in a bottle, then shake or stir until honey is dissolved.

It is important to keep this syrup refrigerated, as storing it at room temperature will cause it to ferment.

Makes 1 cup.

SIMPLE SYRUP

2½ cups granulated sugar

2½ cups bottled or purified water

Simmer together in a saucepan over medium heat, stirring frequently, until sugar is completely dissolved.

Remove from heat and let the mixture cool. Funnel into a bottle and refrigerate.

Makes 1 liter.

SWEET AND SOUR

2 ounces lemon juice

4 ounces lime juice

6 ounces simple syrup (see preceding recipe)

Mix ingredients in a 12-ounce bottle, then shake or stir until syrup is mixed with the juices.

Syrup is ready to use immediately; refrigerate if storing.

Makes 12 ounces.

VANILLA SYRUP

2½ cups granulated sugar

2½ cups bottled or purified water

1 fresh vanilla bean

Combine sugar and water in a deep saucepan.

Cut vanilla bean lengthwise and scrape out the seeds. Add both the seeds and the remainder of the bean pod to the saucepan. Simmer over medium heat, stirring frequently, until the sugar is completely dissolved. Bring to a boil and boil for two minutes.

Remove from heat and let the mixture cool. Funnel, including bean and seeds, into a bottle and refrigerate.

Makes 1 liter.

BAR EQUIPMENT

Stock your bar with the following equipment and you can make any drink in this book.

Citrus peeler—Like a potato peeler, this simple hand-held gadget easily pares off long spirals of cirtus peel used for garnish.

Citrus press—Also known as a citrus juicer. Stainless steel, metal or plastic, this hand-held press will easily squeeze every last drop from a lemon or lime.

Cocktail shaker—A 28-ounce stainless-steel cocktail shaker, which is also known as a tin or Boston shaker.

Cocktail strainer—A perforated stainless-steel strainer with coiled wire that fits snugly over the cocktail shaker. Also known as a wire strainer or Hawthorne strainer.

Cutting board—A small board, either rubber or wood, used for cutting fruit.

Eye dropper—A standard drugstore eye dropper.

Jigger—A two-headed stainless-steel device used to ensure precise measurement of the liquor in your drinks. Jiggers come in different sizes with different lines, so be sure to get one that marks off ¼-, ½-, ¾- and 1-ounce measurements

Juicer—A high-speed electric juicer.

Mixing glass—A sturdy 16-ounce glass.

Muddler—A thick wooden stick that is used to release flavor by crushing mint, citrus and herbs in the bottom of a mixing glass.

Paring knife—A sharp 3½- or 4-inch knife used for cutting garnishes.

Serrated knife—A sharp 6- to 8-inch knife with a serrated blade, used for cutting fruit,

Strainer—A hand-held fine-mesh kitchen strainer.

THE AUTHOR

P Moss is a longtime Las Vegan whose cocktail pedigree includes ownership of Frankie's Tiki Room, as well as the Double Down Saloons in Las Vegas and New York City. A former bartender, he learned early on that cocktail service is best left to those who have the temperament for it. He is a musician and songwriter whose band Bloodcocks UK recently sold out tours of both Japan and Great Britain. He is author of the well-received books *Blue Vegas* and *Vegas Knockout*. *Liquid Vacation* is his first non-fiction book.

THE COCKTAIL CREATORS

Chris Andrasfay hails from Huntington Beach, California, and made an early name for himself behind the bar at the Ocean Club in Manhattan Beach and the Boathouse on the Santa Monica Pier. It was while building his reputation at these beach bars that he came to realize that, above all of the other bottles on the shelf, rum is the happy liquor. Straight, in a punch bowl or in a tiki concoction, he used rum as the kick-starter to bring out the cheerfulness in people. Even after his move to Las Vegas, rum was the guiding force as his career advanced from a bartending gig at rumjungle on the Strip to becoming co-founder of Frankie's Tiki Room.

Allison Hartling grew up in Southern California, a beach girl who listened to Ventures and Dick Dale records, surfed and hung out at the beach. Then the real world called and she moved to Las Vegas as a veterinary surgical technician, eventually switching gears for a career behind the bar. After bartending stints including rumjungle at Mandalay Bay Hotel and Casino, it became clear that rum was calling her. On her nights off she experimented, coming up with her first original tiki drink, the Murky Lagoon, and for her it was a game-changer. A die-hard tiki enthusiast, she has been behind the bar at Frankie's since opening night.

Mike Richardson grew up on a beach in parts unknown and, like many small boys, dreamed of adventure. Too young to hit the road, he kept his ardor up by experimenting with beverage creation, and at age ten came up with an intoxicating elixir of juices and soda that forever hooked him on cocktail culture. Once old enough, he followed this calling to Las Vegas, where he bartended in Strip nightclubs such as Tao. But the nightclub grind eventually wore thin, and needing both a change and a challenge, he followed his dream of adventure to Frankie's, where he has been creating magical elixirs since the bar opened.

ACKNOWLEDGEMENTS

Our heartfelt thanks go out to all those whose efforts contributed to making this book, and the bar that inspired it. To Melo Reola, Tawnya Nilsen, Larry Lava, Jessi Sticken, Brahim Rouas, and Ian Roach for keeping the party going. To Wes Myles, Ryan Reason and Jenn Burkart for their sharp photographic eyes. To Carolyn Hayes Uber, Heidi Knapp Rinella and Sue Campbell for putting it all together. To Dave Cohen AKA Squid for being the ultimate pro. To Amy Prenner for kicking doors down. To Paco Alvarez and Lisa Jacob from the Las Vegas Convention and Visitors Authority. And to Bamboo Ben, Bosko Hrnjak, Crazy Al Evans, Ben "Benzart" Davis, Leroy Schmaltz, Bob Van Oosting, Tom "Big Toe" Laura, Doug Horne, Shag, Ken Ruzik, Holden Westland, Tiki Ray, Buzzy Meeker, Max Fedella, Dirk Vermin, Mark T. Zeilman, Sophia Brewer, The Pizz, Brad Parker, Thor, Billy The Crud, Marcus Pizzuti, Jack Churchill, Vicki Bassham, Von Franco, Patti and Jeff Crane, Truus de Groot, all the girls at the Enchanted Florist, Shaun Kama and Philippe Tilikete.

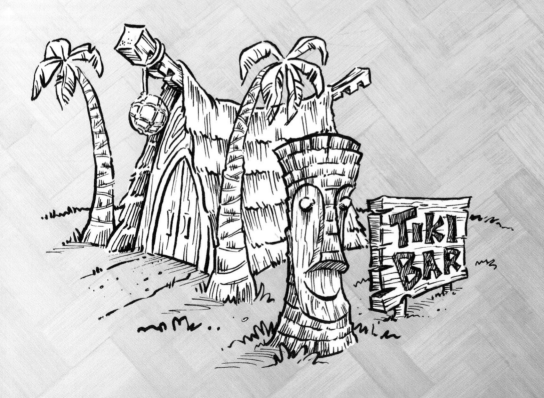

INDEX

DRINKS INDEX